SPREZZATURA

COLUMBIA THEMES IN PHILOSOPHY,
SOCIAL CRITICISM, AND THE ARTS

For a complete list, see page 171.

SPREZZATURA

CONCEALING THE EFFORT
OF ART FROM ARISTOTLE
TO DUCHAMP

PAOLO D'ANGELO

Translated by

SARIN MARCHETTI

Columbia University Press *New York*

Columbia University Press
Publishers Since 1893
New York Chichester, West Sussex
cup.columbia.edu
Copyright © 2018 Paolo D'Angelo
All rights reserved

Library of Congress Cataloging-in-Publication Data

Names: D'Angelo, Paolo, 1956– author. | Translation of:
D'Angelo, Paolo, 1956– Ars est celare artem.
Title: Sprezzatura : concealing the effort of art from Aristotle to
Duchamp / Paolo D'Angelo ; translated by Sarin Marchetti.
Other titles: Ars est celare artem. English
Description: New York : Columbia University Press, 2018. |
Series: Columbia themes in philosophy, social criticism, and the
arts | Includes bibliographical references and index.
Identifiers: LCCN 2017031560 | ISBN 9780231175821 (hardcover :
alk. paper) | ISBN 9780231540346 (e-book)
Subjects: LCSH: Sprezzatura (Aesthetics) | Art—Philosophy.
Classification: LCC BH301.S66 .D3613 2018 | DDC 111/.85—dc23
LC record available at https://lccn.loc.gov/2017031560

Columbia University Press books are printed on permanent and
durable acid-free paper.
Printed in the United States of America

Cover art: Man Ray, Indestructible Object © ARS, NY
Digital Image © The Museum of Modern Art/
Licensed by SCALA / Art Resource, NY

To Gloria

CONTENTS

PREFACE TO THE FIRST EDITION

The creative core of this book is an essay published in 1986 in *Intersezioni*, which I wrote over the course of two years. I suppose one could say that I've been working on the book for twenty years, even though I wrote it in a few months during the spring and summer of 2004.

Although I don't believe that a long gestation is an indication of quality, it is important to note that research in the history of ideas often takes a great deal of time. One never knows, *in advance*, when an idea might go into hiding, or when it will be found again in an unpredictable context. The idea that art, to be called true art, must remain concealed as much as possible—the idea whose history I shall recount in this book—was born in the domain of classical rhetoric, and from there passed through literature on visual arts, behavior, and poetry. But the idea is present in many other fields as well. For example, in the seventeenth and eighteenth centuries we find it widely used in literature on gardens. I did not know this when I wrote that first essay, and only many years later, working on the aesthetic of nature, did I eventually find out the role that this idea played in debates on natural beauty. (To these conversations, I dedicated an essay in *Quaderni di estetica e critica* in 1998.) These are serendipity's

adventures: one looks for something, and finds something else that is no less interesting than the original object of inquiry. This is the beauty of this kind of research.

When one spends a lot of time following the adventures of an idea there is another rewarding result, and that is when the idea ends up inextricably intertwined with friends and colleagues with whom we have discussed it, and who have helped and encouraged us throughout the journey.

For example, when I began writing the essay from which this book was born, I didn't have the faintest idea where it could be published. I did know, though, that in Italy there is a journal committed to the history of ideas, and that one of its editors was Paolo Rossi. I didn't know Paolo Rossi at all (and still today I have only met him briefly at a couple of conferences) as I was a new graduate who had published his thesis on Benedetto Croce's aesthetics (which, as I think about it today, was not the most promising introduction to a philosopher of science who was a pupil of Antonio Banfi). Nonetheless, I wrote to Rossi and proposed my idea, and not only did he encourage me to carry on working, but also, punctually, sponsored the publication of my essay. These are things that cannot be forgotten, and that are even more appreciated when one experiences how difficult it can be, even in the world of academic studies, to receive attention from those with whom one is not directly acquainted.

Just after the essay was published, I sent a copy of it to Luciano Anceschi, who wrote me a letter that I still treasure, in which he considered me to be definitively committed to the method he called the *new critical phenomenology*, which he championed. I do not know whether his supposition had any ground (in fact I believe that it did not), but I gladly took that recognition as implicit praise of my work.

Alongside the masters, there are the friends. With Giovanni Lombardo I have discussed both that first essay and especially the first drafting of this book. To his kindness and friendship I owe so much. I can confidently say that thanks to him the part of this volume on classical sources is infinitely better than it would have been if I had to count on my own expertise. With Nuccio Ordine, starting with that original essay, I also began an exchange of suggestions and ideas that has been very useful to me, and that has gone far beyond the theme of *artem celare*. Valerio Magrelli led me to discover the importance of the theme of concealed art in the work of the little-known writer Joseph Joubert. For quite some time I had been discussing the connections between art concealment and the *je ne sais quoi* with Stefano Velotti, especially while working together on the volume *Il "non so che": Storia di un'idea estetica*, which was generously accepted for publication by Luigi Russo for his press, Aesthetica, in 1997. When I look at the title and content of Velotti's last book, *Storia filosofica dell'ignoranza*, it appears that the theme of "I don't know what" is clearly still as important to him as it is to me. When my essay was published in 1986, Carlo Ferrucci pointed out that limiting the research to the eighteenth century was somewhat specious. Eventually I admitted that he was right, even if for different reasons than those he advocated at the time. Lastly, I discussed the history of ideas and *Begriffsgeschichte* many times with Michele Cometa, which led to our collaboration on these themes for his *Dizionario degli studi culturali*.

To all these friends, and to the many others who have shared ideas and inspiration, I express my deepest gratitude.

NOTE TO THE SECOND
ITALIAN EDITION

When the first edition of this book was published, I was unsure whether to translate the Latin title. The publisher's friendly insistence persuaded me against it. Stefano Verdicchio proved to be right: if the book has done well enough to warrant a second edition, it means that readers were not discouraged. After all, *ars est celare artem* is a simple Latin expression, at least for those who speak Italian. Less obvious is the problem, or cluster of problems, that hides behind those words, which the book tries to disentangle, not only by engaging with the history of ideas, but also by striving to show that the paradox of concealment reveals an important conundrum of the existence and persistence of art, an activity at once useless and indispensable.

In the preface to the first edition, I pointed out that research in the history of ideas is never complete. Thus, in the years since the book's publication, I have closely followed the advancements in this area, and I have incorporated those into this second edition. Also, the bibliographical references and footnotes have been updated to include the most recent works on the themes in this book.

I owe thanks to the many people who have reviewed and discussed this book in newspapers and journals. Among them are friends and colleagues already cited in the preface to the first edition, to whom I would like to renew my gratitude. I would especially like to extend my renewed gratitude to the man who was at the top of that list, the late Paolo Rossi.

Rome
December 31, 2013

SPREZZATURA

1

CONCEALMENT

We might begin with a dive from a springboard. What makes a dive a *beautiful* dive? What is it that, in competitions, ensures that a dive gets a high score? Let us look for an explanation in the words of a writer who, in his early years, was an excellent diver as well. In *Letteratura e salti mortali*, Raffaele La Capria argues that for a dive to be a *beautiful* dive, one that is to be appreciated by the judges, it is necessary, of course, that the *figure* is perfect in the approach, as much in the flight as in the entry. Woe if the body is disorganized, woe if some part of it is not perfectly aligned! The diver's jump from the springboard must be the highest possible, the flight must be graceful, and the entry must be *smooth*, plowing through the water surface with the proper grade. Almost every dive, at least in competitions, is a somersault, and requires not only athleticism and training but also self-control, courage, and concentration. Each dive is a tour de force, a display of skill, determination, and strength. But all of this is still not enough to make a dive *beautiful*. What must be present is a peculiarity, a feature that is at the same time the most indefinite, the least definable, and the most elusive. It is above all to this peculiarity that La Capria wants to draw our attention, and his entire discourse

is aimed at its characterization. In his words, "Thus a dive is a tour de force . . . but it must possess a quality if it is to be a beautiful dive: it must be performed, regardless of its difficulty level, with *souplesse*, as my trainer used to say, or sweetness, as I felt it, and grace. Without effort or, if the effort is present, it must remain unseen. The dive must be performed with the same smile Flo Griffith had while running the hundred-meter final, a smile that she showed in the last thirty meters and that for me was one of the most unforgettable things of the 1988 Olympic Games."[1]

Obviously, this kind of observation is not only made in the context of dives. We refer to a similar, even identical, principle when we think about public behavior. We think that truly refined conduct consists of an unforced ease, a kind of effortlessness and spontaneity of manners, and an absolutely nonrigid respect of conventions, always ready to bend according to opportunity, situations, and circumstances. When remembering the industrialist Gianni Agnelli on the first anniversary of his death, Sergio Romano cited exactly this ability to conceal his own talent as one of the primary traits of the man who, for decades, embodied the icon of *grand seigneur* for all Italians. Romano writes that Agnelli played this role, or, better, his various roles of businessman, Italy's "ambassador" abroad, and political compass, with nimbleness and distance, that is, with an ability to conceal his own commitment and give the impression that what he did, he did effortlessly without being overengaged.[2]

Similarly, in interior design there is a particular kind of care that consists of an apparent carelessness, a shabby elegance, that shows itself when, as Alvar González-Palacios points out, "elegance is imposed by chance, and, despite it perhaps being formal in tone, it can at the same time reflect a sort of indifference to details, producing what is called 'shabby chic.' This is a particular

kind of chic, made up of exquisite objects and torn sofas, loose and overwashed covers, stained or faded lampshades, an unaffectedness resulting from the use and abuse of inventiveness."[3]

But the field in which it is most natural for us to point to the ability to dissimulate one's own mastery, and to spurn affectation, is that of the arts. That art has to be concealed represents for us an understanding and depiction of art that became prevalent in contemporary culture, that is, art as fine and great art. A diver is not the only one who must dissimulate effort and struggle. This kind of dissimulation is required of a dancer as well: it is not good if her face shows a grimace from fatigue or pain, as everything must appear effortlessly, lightly, smoothly, and naturally performed. And we could say the same about a painter, a writer, or a poet. No wonder Raffaele La Capria's book is titled *Letteratura e salti mortali* (*Literature and Somersaults*): the point of his argument is that, just as dives must be performed with an apparent ease, so in literary works the effort, the quest for effect, and the display of skills must remain unseen. Referring to the amount and kind of work that is required to complete a musical or literary piece, Thomas Mann wrote in *Doktor Faustus*: "The appearance of art is thrown off. At last art always throws off the appearance of art." *Facilement, facilement,* Frederic Chopin is said to have instructed his students when they sat at the piano, even when they were about to play extremely difficult pieces. Those who, in art, grow excited about the overcoming of difficulties, technical skills, or the ostentation of abilities—as happens with virtuosity, a phenomenon typical, though not exclusive, of musical performance—end up mistaking the artist for the tightrope walker. They would underappreciate form in their (always quite obtuse) admiration of the crafty ability of execution. This kind of wonder is hopelessly naïve, and pertains to simpletons and children, who, as we learned in a recent study, are indeed

unable to appreciate art that conceals its sophistication behind an apparent simplicity, and are much more disposed to value what is patently complex, is duly executed, and manifests the exercise of skills.[4]

In order to express this kind of naturalness, which is not a gift from nature but the result of serious study, and to illustrate the necessity that art, skills, and mastery remain concealed and not be shown off boastfully, the Italian language has a beautiful and ancient word, one of those words that makes a language unique: *sprezzatura*. In its original meaning, which is the one that interests us, this word is not related to scorn or disdain (even if it is sometimes used precisely in this sense). Rather, since it is etymologically connected with disregard and heedlessness, we should bear in mind expressions such as "heedless of danger": one is heedless of art, ability, and ostentation, just as she is heedless of a dangerous situation, that is, she is not ignoring the situation but preventing it from making her behave rigidly or with apprehension. The connection to disregard—a connection that creates difficulty in the very translation of the word— becomes clear if we take a look at some of its lexical variations. For example, in his *Letters from Virgil*, Saverio Bettinelli (in the middle of the eighteenth century) compares two poets, one of them, "because of an unknown harshness and violence impressed to his verses, seemed somewhat gaining in force and gravity," while the other could benefit from "a certain heedlessness [*sprezzatura*], simple and gracious in appearance." Bettinelli concludes, "in the former one could sense too much of the struggle and study, while in the latter appreciate too little of it."[5]

But, one might ask, what is *sprezzatura* if not disregard? Giacomo Leopardi talks about it as "negligence, certainty, carelessness, and I would even say ignorant confidence." In his *Dizionario*, Niccolò Tommaseo defined it as a "manner of doing and

talking that appears to be neglectful, but that often consists in masterly ease." *The Great Italian Dictionary* by Salvatore Battaglia refers to it as an "intentional carelessness, more apparent than real, that gives naturalness and spontaneity to a literary work or a style, and also a kind of elegance that is perceived as much more refined as it is artificial and studied." Cristina Campo warns us against the danger posed by apparent synonymies:

> [What could be called its] "sister word," namely, *elegance*, doesn't acknowledge *sprezzatura*'s creative quality, its fresh communicative flame; *manner* restricts it in the domain of deliberation; *ease* dissolves it in gestures. *Carelessness* is more similar, but it fills up only *sprezzatura*'s hollow, negative, and thus temporary shape. *Sprezzatura* is actually an overall moral stance that, just like the very word, needs a context that is nearly lost today, and that, again like the word, is in danger of fading away together with it.[6]

Like many other words, this subtle and intense word was not anonymously born to the language. There was a time in which it was considered a neologism, a creation of a single author's mind. And it is precisely as a neologism that Baldassarre Castiglione, who invented or used it for the first time in his famous *Courtier*, presented it. "And, *to use possibly a new word*, to practise in everything a certain '*nonchalance*' [*sprezzatura*] that shall conceal art and show that what is done and said is done without effort and almost without thought."[7] Let's try then, as Cristina Campo suggests, to reconstruct the *context* of the term *sprezzatura* within the literary work in which it first appeared.

The context is the first book of the *Courtier*, nearly at the beginning of the dialogue. The chosen company of gentlemen and ladies gathered at the Palazzo Ducale in Urbino begins to play the "game" of "portraying a perfect courtier." They only had time

to discuss the equestrian and military exercises that should be expected of the perfect courtier, and to enumerate some of the physical and moral qualities he should possess. Nonetheless, they immediately realized that these qualities are nearly worthless if not accompanied by a particular kind of constraint, a *quality* of a different order. This quality, which must permeate all the others, since in a sense it is a prerequisite for them, had been given a familiar and ancient name, namely, *grace*. But even if in this case the name is ancient ("grace" stands for the Greek *charis*, the Latin *gratia* or *venustas*), its meaning is not obvious or unequivocal at all. Rather, *grace* in behavior seems to be something as mysterious and indefinable as the homonymous *grace* in the theological sense of the particular kind of benevolence and help that God concedes—or doesn't concede—to human beings according to his unfathomable plan. At the very beginning of the *Courtier* grace is considered in this way as well, that is, as an innate quality, resulting from an inexplicable gift, something intended to remain cryptic and indefinable or something that can be defined only in a tautological way. "From the very force of the word, it may be said that he who has grace finds grace."[8] But a *distinguo* (distinction) is drawn immediately afterward. While it is very true that for many grace is a natural gift rather than an ability that could be acquired by learning, for others, I mean for those who aren't blessed with it and thus have to acquire it, is there a way to learn to be graceful at all? Count Ludovicus's answer represents a fine rhetorical masterpiece. At first he hedges a bit: "I am not bound to teach you how to become graceful, or anything else; but only to show you what manner of man a perfect courtier ought to be." Knowing how to define the qualities of a perfect courtier doesn't necessarily imply that one knows how to teach someone to acquire these qualities. But, "although it is almost a proverb that grace is not to be learned"

(the count can admit that), to some extent at least it can be acquired from study and exercise, and he can even give a *universal rule* for grace:

> But having before now often considered whence this grace springs, laying aside those men who have it by nature, I find one universal rule concerning it, which seems to me worth more in this matter than any other in all things human that are done or said: and that is to avoid affectation to the uttermost and as it were a very sharp and dangerous rock; and, to use possibly a new word, to practice in everything a certain nonchalance [*sprezzatura*] that shall conceal design and show that what is done and said is done without effort and almost without thought. From this I believe grace is in large measure derived, because everyone knows the difficulty of those things that are rare and well done, and therefore facility in them excites the highest admiration; while on the other hand, to strive and as the saying is to drag by the hair, is extremely ungraceful, and makes us esteem everything slightly, however great it be. Accordingly we may affirm that to be true art which does not appear to be art; nor to anything must we give greater care than to conceal art, for if it is discovered, it quite destroys our credit and brings us into small esteem.[9]

Grace and *sprezzatura*. The first term, as discussed, has a long history, and should be thought of in relation to the concept of beauty. If through the centuries beauty has been identified with order, measures, proportions, and hence with relations and rules that can be expressed numerically (think, for example, of Polykleitos's canon and its implementations in Vitruvius's works, which found so many applications in the course of history), *the latter*, *sprezzatura*, expresses the *fascination* and *splendor* that emanate from beauty. This term lends credence to the idea that the

appeal of beauty cannot be fully explained through proportional relations, order, and unity. Indeed, it is the case that even out-of-proportion or irregular things might well be appreciated, while, on the other hand, there are regular and proportioned things that might not, as Catullus knew only too well when he said, comparing Quinzia with Lesbia, that the former has many perfections, but not true beauty, because she has *nulla venustas*, that is, no grace.[10] Pliny the Elder, in glorifying the art of the renowned ancient painter Apelles, writes that he

> surpassed all the painters that preceded and all who were to come after him. . . . His art was unrivalled for graceful charm, although other very great painters were his contemporaries. Although he admired their works and gave high praise to all of them, he used to say that they lacked the glamour that his work possessed, the quality denoted by the Greek word *charis* [Latin *gratia*]; and that although they had every other merit, in that alone no one was his rival.[11]

In the Italian Cinquecento, and thanks to Castiglione's work, grace plays a prominent role in the aesthetic discourse. Sometimes it has been understood as the distinctive trait of spiritual beauty as opposed to physical beauty, as in the work of Mario Equicola, Judah Leon Abravanel (Leo the Hebrew), and Benedetto Varchi; sometimes, as in Agostino Nifo, it is at once physical and spiritual, or, as in Vincenzio Danti, it derives from the "internal parts" of physical beauty itself. Even if grace has often been distinguished from beauty, it was not always in opposition to it, and at times it appeared as the expression, the revelation, or the very effect of beauty, as in Giovanni della Casa's *Galateo*. But some (Agnolo Fiorenzuola in his *Discorsi della bellezza delle Donne* being a case in point) emphasize the mysterious character

of grace as opposed to beauty's predictability and quasi-numerability, hence defining grace through a locution that, despite its vagueness, is fated to have a unique legacy: *un non so che* (a certain something).[12]

Despite a comprehensive investigation of the role of the notion of grace from the sixteenth century to the eighteenth, it still remains among the *desiderata* of the history of aesthetic ideas.[13] I won't be dealing with this concept here. Nor will I discuss those positions that declare that grace has an indefinable nature. Rather, I am interested precisely in the paradoxical definition of grace proposed in the *Courtier*, which identifies it with the principle of *art concealing art*, hence capturing the very essence and function of *sprezzatura*. Now, is this principle a *novelty* as well, just like the word chosen for it by Castiglione? Or does it have a long history? And, moreover, did it leave a legacy in the subsequent centuries? Will it become a motto that summarizes important reflections, or is it rather just an isolated *boutade*?

Even at a quick glance, it seems highly probable that the *Courtier* represents an excellent starting point for tracing the *subsequent* history of the principle of *artem celare*. It is quite well known, and had a strong influence in Italy and a large circulation in Spain, France, England, and the German-speaking countries. Due to this we can be almost certain that both *sprezzatura* and art concealing entered the larger European aesthetic debate as well.[14] Castilian, French, German, and Latin translations immediately faced the difficulty of how to use the word *sprezzatura*. French is perhaps the language with the closest word: *nonchalance*. When "translating" the *Courtier* into modern Italian, Aldo Busi and Carmen Covito use precisely that French expression: "I could exhume an old neologism and say *sprezzatura*, or I could use a foreign word and say *nonchalance*, but if the purists get itchy, I would rather say a certain ease."[15] *Nonchalance*

is quite a good option, because it expresses the sense of a self-assured carelessness, even though it leaves out the heedlessness (*sprezzo* in Italian) of danger; in Singleton's modern English translation the term is not translated and the French equivalent, *nonchalance*, is in brackets. In any event, *nonchalance* is better than *mépris* (or *mesprison*), which expresses too much contempt, but nonetheless can be found in sixteenth-century translations, as well as in some modern ones. The French *dédain* (English *disdain*, but *sprezzatura* is not disdain) is even more inappropriate, while *néglicence* only partially conveys the concept (*sprezzatura* is negligence, but a paradoxical diligent negligence, or a negligent diligence).[16]

The misleading term *deprecio* (contempt) has been mostly used in Castilian, while in other cases the antonyms *affettazione* and *sprezzatura* are rendered with the opposition *cuidado* and *descuido*.[17] *Verachtung* (contempt) is again the choice of the second of the two sixteenth-century German translators, namely, Noyse, while the first translator, Kratzer, uses *Unachtsamkeit*, which is a little more accurate but still expressive only of *sprezzatura*'s sense of inattention, and not its stress on simulation. English has many possibilities, and almost all of them have been employed. Modern versions use, for the most part, the terms *carelessness* and *effortlessness*, or, as we have seen, the French *nonchalance*. *Negligence* is also a possible choice even if, as always, it misses the paradoxical sense of care and attention required by *sprezzatura*'s particular kind of negligence. In his seminal translation, which indeed was the first English one, in order to say that the courtier has to exhibit an unconcerned behavior, Sir Thomas Toby put aside all these possibilities and opted for the term *disgracing*, although at times he preferred *recklessness* (*reckless* being a synonym of *careless*). However, both terms have been judged "lexically and culturally" inadequate.[18]

In Italy, it took time for the term *sprezzatura* to get some currency. While today it is almost unanimously considered one of the pivotal concepts in the *Courtier*, still drawing attention from scholars,[19] in 1562 Lodovico Dolce didn't deem it worthy of appearing in his *Table of the Most Important Contents and Maxims in the Courtier*.[20] But, if not the word, the theme of *artem celare* reverberated immediately in the literature on manners and behavior. Alessandro Piccolomini's *Raffaella*, a dialogue dedicated to female education and behavior printed in 1539, reflected the *Courtier* almost literally:

> In brief it will avail her much to strive that in all things she leaves not the middle way and eschews all affectation the most she may. To cleanse and attire oneself openly in the house and that in the presence of others is to show a *certain contempt and lack of thought* for what is done whether for adornment or other cause, which I know not how to describe to you otherwise. Yet in this, also act with judgment, for to go carelessly in all would be perchance a fault no less than to go affectedly.[21]

And, in turn, a few decades later, Stefano Guazzo's *Civil Conversazione*, another very influential handbook on public behavior, opens with an indirect but explicit quotation of Castiglione's aforementioned passage: "In this Discourse you have not in the least deviated from the Character of a perfect Courtier, whose Excellence it is, to do all Things with such an early Grace, that tho' what he does, seems merely casual and by Accident, yet it is really the Effect of the most skillful Judgment."[22]

These are just two among many possible examples, but I believe they are sufficient to persuade the reader that most occurrences of the principle of *ars est celare artem* that we shall encounter in the following chapters when addressing eighteenth- and

nineteenth-century authors can be traced back, in one way or another, to the *Courtier* passage with which we began. Less evident, though, yet still true, is that this passage can also function as an excellent starting point for tracing backward the history of the principle. I am not interested in pointing out that it is obviously possible to find some close antecedent of the principle. One example is the *De iciarchia*, a text written by Leon Battista Alberti in his last days, in which he addresses, in addition to government, individual conduct. There is a passage of the text that Ettore Bonora once identified as one of the forerunners of Castiglione's *sprezzatura*:

> There are things in which a man must give all of his spirit, and diligence, and be totally committed in order to do them well. And it seems that doing them well means here to present oneself with simple modesty and refined attitude, so that those things would delight the observer. Such things are horse riding, dancing, walking, and the like. But in doing them, one must above all moderate gestures and facial expressions, movements and bodily figure as carefully as he can and with the most disciplined art, so that nothing appears to be done with planned craftiness, so that the observer would read this skill as a natural gift.[23]

Rather, I am interested in highlighting a less predictable circumstance, and that is the fact that in the text, Castiglione himself makes two references, and gives many hints, that disclose an entire prehistory of the idea of *artem celare*. Right after the passages about *sprezzatura* and art concealing, the *Courtier*'s speaker says: "And I remember having once read that there were several very excellent orators of antiquity, who among their other devices strove to make everyone believe that they had no knowledge of letters; and hiding their knowledge they pretended that

their orations were composed very simply and as if springing from nature and truth rather than from study and art; which, if it had been detected, would have made men wary of being duped." And then he adds: "It is said also to have been proverbial among some very excellent painters of antiquity, that over diligence is harmful, and Protogenes is said to have been censured by Apelles because he did not know when to take his hand from the tablet."[24] These quotations represent two possible directions for our research: the latter encourages us to investigate the theory of figurative arts, while the former addresses ancient rhetoric. Let's start with rhetoric.

2

PART OF ELOQUENCE
IS TO HIDE ELOQUENCE

Where might the Count Ludovicus have found the information about the "very excellent orators of antiquity," and who might these orators be? In his introduction to the *Courtier*, Amedeo Quondam reminds us that Castiglione's "ideal library . . . [is] of average dimensions, with a marked classical structure, dominated by Cicero"; Richard Lanham, for his part, points out, in an earlier work, that Castiglione's text can be read as a treatise on rhetoric, and that in this respect it deliberately lies "in the Ciceronian shadow of *De oratore*."[1] Some parts of the text, for example, the long excursus on jokes made by Bernardo Bibbiena, are almost a replication of the most systematic among Cicero's works on rhetoric.[2] And indeed, it is in *De oratore* that we find the information recalled by Castiglione.

At the beginning of the second book, Cicero recalls that he and his brother Quintus Crassus

> did not so much wish to be thought to have learned nothing, as
> to have the reputation of looking down upon learning, and of
> placing the wisdom of our own fellow-countrymen above that of
> the Greeks in all departments; while Antonius held that his

speeches would be the more acceptable to a nation like ours, if it were thought that he had never engaged in study at all. Thus the one expected to grow in influence by being thought to hold a poor opinion of the Greeks, and the other by seeming never even to have heard of them.[3]

This episode is also recounted in Quintilian's *Institutes of Oratory*: "Among the ancients, indeed, it was a practice to dissemble the force of their eloquence, a practice which Marcus Antonius recommends, in order that more credit may be given to speakers and that the artifices of advocates on behalf of their clients may be less suspected."[4]

The orators mentioned by Cicero, and recalled in the *Courtier*, want us to believe in their mediocre education to make us think that they didn't master any rhetorical device at all: in the pre-Ciceronian period, to pretend not to be familiar with Greek amounted to denying knowledge of the very subtleties of rhetoric, which was still considered a typically Hellenic *ars*. This simple device is meant to conceal or openly deny the possession of rhetorical skills, so that the listener would not be suspicious and, if the argumentation turned out to be persuasive, would attribute it to the evidence of facts rather than to the orators' skilled presentation or to the seductiveness of the speech itself. This device is very common in all types of pleadings. The exordium of the *Apology of Socrates* is a clear example of this. Socrates's accusers have already warned the judges against his rhetorical ability, full of subtleties and thus questionable regarding facts. Socrates (not by chance the master of irony, which in Latin is called *dissimulatio*) reverses the terms of the problem by affirming that his speech will be free of any device, and that he will only speak the truth, while his accusers are skillful and persuasive speakers who can easily give the impression of being persuasive even

though they don't speak the truth.[5] But, taking a sudden turn into a completely different context and territory, we may look also at Dmítrij Karamazov's defense, pronounced by his pleader, at the end of Dostoyevsky's great novel. He begins with these words: "I should really have kept this point for the end of my speech, for my final summation, but I will explain my idea now, at the outset, because I have a weakness for going straight to the point, without trying to save any possible effect for later, without economizing my ammunition"; he thus explicitly denies having rhetorical abilities ("I hope you will forgive me this trivial simile . . . because I am not very good at elegant phrasemaking"), while simultaneously attributing them to the prosecutor ("the highly talented prosecutor," "my talented friend the prosecutor").[6]

We can easily understand why among the three genres of ancient rhetoric—the deliberative (which is related to discourses given at assemblies, and pertains to political decisions), the epideictic (referring to ceremonial discourses on public occasions), and the forensic (encompassing all speeches pronounced in tribunals)—the last, the *genus iudiciale*, represents the very foundation (and perhaps womb) of the principle of *dissimulatio artis*. "For even in those oratorical compositions, which are doubtless based in some degree upon truth, but are adapted to please the multitude (such as the panegyrics we read and all that epideictic kind of eloquence)," Quintilian writes, "it is allowable to use great elegance, and not only to acknowledge the efforts of art (which ought generally to be concealed in forensic pleadings), but to display it to those who are called together for the purpose of witnessing it."[7] Indeed, it is safe to assume that in forensic rhetoric all the skills involving eloquence are directed to the deception of the judges: pleaders and judges sit face to face in opposition like suspicious enemies. The judge suspects that the

pleader is disguising the truth behind the seductiveness of her oratory skills, while the pleader strives to convince the judge that persuasion results from the simple truth of the facts. Thus, in forensic rhetoric the ability to *conceal art* is fundamental, to dissimulate all rhetorical skills in order to make the listener believe that one is speaking in the most simple and spontaneous way. But the dissimulation of art in fact requires a great deal of art, according to the *Institutes of Oratory*: "We must take no less care, also, that we may not excite suspicion in the exordium; therefore, no appearance of study ought to be shown in it because all art on the part of the orator seems to be directed against the judge. But to avoid the suspicion of using art is the achievement of the highest art."[8] The same recommendations are given in Philostratus' *Life of Apollonius of Tyana*: "For forensic art, if too obvious, is apt to betray him who resorts to it as anxious to impose upon the judges; whereas if it is well concealed, it is likely to carry off a favorable verdict; for true cleverness consists in concealing from the judges the very cleverness of the pleader."[9]

The authority of the speaker is fundamental in forensic rhetoric, and therefore the pleader must dispel all doubts that she is indeed distorting the facts. As it is written in Quintilian's *Institutes of Oratory*,

> But while the authority of the speaker becomes thus of the highest efficacy if, in his undertaking the business, all suspicion of meanness, hatred, or ambition be far removed from him, it is a sort of tacit commendation to him if he represents himself as weak and inferior in ability to those acting against him. . . . For there is a natural feeling on behalf of those oppressed, and a conscientious judge most willingly listens to an advocate whom he does not suspect of any design to draw him from justice. Hence arose that dissembling of the speakers of antiquity to conceal their eloquence,

so extremely different from the ostentation of our times [*inde illa veterum circa occultandam eloquentiam simulatio, multum ad hac nostrorum temporum iactatione diversa*].[10]

It is possible to draw a list of norms from the general principle of *dissimulatio artis* that regulate the application of the principle to the various elements of rhetoric.[11] Again, we can find them codified in Quintilian's work. In the *dispositio*, that is, in the ordered disposition of proofs within a discourse, the principle of art concealing reveals itself as crucial from the very outset. In fact, a patently studied positioning betrays excessive care and instills the suspicion that the pleader is giving great importance to the form of the discourse in order to conceal the intrinsic weakness of her case. A pleader's speeches must at least *appear* to be extempore and not organized to the last detail (as indeed they always are): "We should not always adopt a partition, first, because most observations are more pleasing when they appear to be conceived in the moment, and not brought from home."[12] This idea was already asserted by the author of *Rhetorica ad Herennium*, the first Latin treatise on rhetoric:

> We shall be using the enumeration when we tell by number how many points we are going to discuss. The number ought not to exceed three; for otherwise, besides the danger that we may at some time include in the speech more or fewer points than we enumerated, it instills in the hearer the suspicion of premeditation and artifice, and this robs the speech of conviction.[13]

Cicero holds that to emphasize the transition between arguments and to state the proofs too clearly is harmful, inasmuch as it reveals the speaker's technique, and is tedious:

But the handling should be diversified, so that your hearer may neither perceive the art of it, nor be worn out by too much monotony (*ne aut cognoscat artem qui audiat aut defatigetur similitudinis satietate*). . . . You should sometimes draw your conclusion, and sometimes abandon them to pass elsewhere; often it is better not to formulate expressly, but to make it plain, by affirming the underlying principle, what the formulation would have been. . . . As a rule you should conceal the intervals between successive proofs, to prevent them from being counted, so that, though separate in fact, they may seem blended in statement.[14]

The more the different parts of a forensic oration resemble the epideictic genre, the more they betray the display of art. For example, in the preamble it is acceptable that the speech appears to be prepared, because in many cases it would be utterly impossible to believe the opposite. On the contrary, in the *narratio*, the narrative account of what has happened, one should not give the impression that there is something planned in advance: "We must especially avoid, therefore, in this part of our speech, all suspicion of artifice [*omnis callidatis suspicio*] (for nowhere is the judge more on his guard) so that nothing may appear fictitious or studied, but that all may be thought to emanate rather from the cause than from the advocate. But this manner our modern pleaders cannot tolerate; we think that our art is lost if it is not seen, whereas art, if it is seen, ceases to be art [*perire artem putamus, nisi appareat, cum desinat asr esse, si apparet*]."[15] Cicero of course championed this approach: In describing Milo's conduct, Cicero succeeds in obtaining the desired effect with less ostentatious means, namely, by "the familiar and ordinary words which he uses and his well concealed art [*arte occulta*] in adopting them. For if the particulars had been stated

in other terms, they would have warned the judge, by their very sound, to be on his guard against the pleader."[16]

Also in the *actio*, that is, in the recitation of a speech (which is indeed close to acting), one must avoid all affectation, since the orator must not look like an actor playing her part:

> It is not even every gesture or motion that is to be adopted from the actor, for though the orator ought to regulate both to a certain degree, yet he will be far from appearing in a theatrical character and will exhibit nothing extravagant either in his looks, or the movements of his hands, or his walk. If there is any art used by speakers in these points, the first object of it should be that it may not appear to be art [*Nam si qua in his ars est dicentium, ea prima est, ne ars esse videatur*].[17]

The real triumph of *dissimulatio artis* takes place in the *elocutio*, since the goal here is to conceal the *ornatus*, that is, the whole set of figures adorning the speech. In fact these are the figures conveying the "artistic" character of the rhetorical speech in the first place. As a consequence, in the *elocutio* one should be very careful not to appear refined, mannered, and affected, where particular attention is to be given to the dissimulation of clauses:

> It is a sort of versification to lay down one law for every species of composition, and it is not only a manifest proof of affectation (the very suspicion of which ought carefully to be avoided), but also produces weariness and satiety from uniformity. The sweeter it is, the sooner it ceases to please, and the speaker, who is seen to make such melody in his study, loses all power of convincing and of exciting the feelings and passions. . . . Accordingly, some of our composition should be purposely of a looser kind, so that, though

we may have labored over it most carefully, it appears to be effortless [*et quidem illa maximi laboris, ne laborata videantur*].[18]

Dionysius of Halicarnassus praised Lysias for his supreme ability to appear natural exactly when greater study and application were required of him:

The distinctive nature of its melodious composition seems, as it were, not to be contrived or formed by any conscious art, and it would not surprise me if every layman, and even many of those scholars who have not specialised in oratory, should receive the impression that this arrangement has not been deliberately and artistically devised, but is somehow spontaneous and fortuitous. Yet it is more carefully composed than any work of art. For this artlessness is itself the product of art: the relaxed structure is really under control, and it is in the very illusion of not having been composed with masterly skill that the mastery lies.[19]

In *De oratore*, Cicero says that the listener should pay attention to *verba et sententia* (words and sentences), and not to the *numerus*, that is, to the rhythm of the speech. Elegance, as Quintilian adds, is appreciated if spontaneous, otherwise it is harmful to the very efficacy of the speech: "Yet it is not to be understood that regard is to be paid only to words, for I must meet and stop those . . . neglecting to attend to the study of things, which are the nerves of all causes, consume their lives in an empty application to words, making it their object to attain elegance, which is, indeed, in my judgment, an excellent quality in speaking, but only when it comes naturally, not when it is affected."[20] A particularly incisive way to conceal the *ornatus* consists of ensuring that ornaments, figures, and all rhetorical devices are appropriate to the context in which they appear. The

best antidote to affectation is thus a strict observance of πρέπον ("the proper"), that is, a respect for what fits the disposition and the condition of the listener, the orator, and the nature of the subject itself. In particular, one must be very careful to avoid those artifices unsuitable to the particular emotion that the speaker is trying to convey to the audience or only pretending that she is really feeling. The orator draws on the emotions of the audience so the listener, in order to be genuinely sympathetic to somebody's pain, is convinced that such pain is authentic. In the presence of a suspicion of pretense, the intended effect would be in fact irremediably compromised, as happens to Hamlet when he hears Laertes's overpolished words before Ophelia's grave: "who is he whose grief / bears such an emphasis?"[21] When passionate feelings are involved, excessive care for formality is harmful, as it instills the doubt of falsity: "Would anyone endure," Quintilian writes,

> hearing an accused person in danger of losing his life . . . indulge in frequent metaphors, in words either of his own coining or studiously fetched from remote antiquity, in a style as far removed as possible from common usage, in flowing periods and florid common places, and fine thoughts? Would not all such elegances destroy the appearance of solicitude natural to a man in peril and deprive him of all sympathy, which is necessary, even for the innocent? Would anyone be moved by his fate, if, in so perilous a situation, he seemed to be swelling with vanity and self-conceit and was making an ambitious display of oratory?

Most rhetorical devices are indeed intended to please, but "when a speaker has to labor to excite emotions of indignation, hatred, or compassion, who would endure hearing him rage, lament, or

supplicate in studied antitheses, balanced clauses, and similar cadences? In such cases, affected attention to words destroys all trust in his expression of feeling, and when art shows itself, truth is thought to be absent [*et unbicumque ars ostentatur, veritas abesse videatur*]."[22]

The aforementioned examples suggest that the principle of *artem celare*, even though it has frequent applications in forensic rhetoric, nonetheless shows a pronounced tendency to spill over into the context of the *genus iudiciale*, becoming a principle of rhetoric in general. The credibility and suitability of speech are not specific aims of forensic rhetoric, but rather pertain to all *ars rhetorica*. The principle that art must be concealed in the domain of rhetoric for the sake of efficacy is often expressed in general terms, and can be said to be as ancient as rhetoric itself. Indeed, the principle even appears in the fundamental text of *techne rhetoriké*, namely, in Aristotle's *Rhetoric*. In the third book, Aristotle opposes poetical and rhetorical elocutions, and this prompts him to claim that in poetry, some pronounced devices, such as particularly inventive metaphors, are admitted, while in rhetorical discourse they should be avoided, since artifice must remain concealed in prose:

> Even in prose, the style, to be appropriate, must sometimes be toned down, though at other times heightened. We can now see that a writer must disguise his art and give the impression of speaking naturally and not artificially. Naturalness is persuasive, artificiality is the contrary; for our hearers are prejudiced and think we have some design against them, as if we were mixing their wines for them. We can now see that a good writer can produce a style that is distinguished without being obtrusive, and is at the same time clear.[23]

Again, in prose, any artifice must be concealed, that is, veiled. Long, unseasonable, frequent, and therefore unnecessary epithets, according to Aristotle, "in prose are . . . lacking in appropriateness or, when spread too thickly, plainly reveal the author turning his prose into poetry." For the sake of persuasiveness, the use of too many similar devices should also be avoided. "For instance, if your words are harsh, you should not extend this harshness to your voice and your countenance and have everything else in keeping. If you do, the artificial character of each detail becomes apparent; whereas if you adopt one device and not another, you are using art all the same and yet nobody notices it."[24]

The good orator, like a refined person, shows her mastery in the ability to employ the right dose of humor and jokes. Brilliant and sharp but nonoffensive manners are precisely what characterize the *urbanitas* of the socialite (and indeed in Greek they are called αστεια, deriving from άστυ, "city," just like the Latin *urbanitas* derives from *urbs*), which is opposite to both uncouthness and buffoonery. In this respect, Aristotle says that the difference between "urban" and uncouth persons resembles the difference between ancient and new comedy: while the former is based on vulgar gags at the limits of obscenity, the latter replaces insults with veiled and subtle allusions.[25]

Beginning with the Aristotelian passages quoted earlier, the idea that art must be concealed has become one of the most general principles of rhetoric, or, to use Castiglione's words, a *regula universalissima*. To dissimulate one's own rhetorical skills is important in forensic discourse, but also, for example, in political (or deliberative) discourse. Marc Antony's speech in Shakespeare's *Julius Caesar* ("I'm no orator, as Brutus is") is a remarkable example of this. Stefano Guazzo's *Civil Conversation*, which as we have already observed owes much to the *Courtier*, applies

the principle of art concealing to ordinary conversations: some people simply have the ability to speak clearly and pleasantly, while others are obscure in their very attempt to appear pleasant. This unwanted effect derives from

> affectation, which ought principally to be avoided, as a thing both odious and fruitless. . . . Sometimes it happens, that such a matter arises in discourse, that a sort of negligence [*sprezzamento*] in the choice of words, is more acceptable than too curious an exactness. And sometimes common and familiar phrases, illustrate the matter in hand, much better than magnificent and high-sounding words can do. However, I will not maintain, that a man need take no care how he speaks; for he is as much to blame, who talks at random, as he who is over-circumspect; and it is as great a fault, in common and known matters, to use an affected language, as in affairs of weight and moment, to show and inconsiderable negligence. Whereas a man of good judgment will know how to avoid these extremes, and, according to time and place, to make use of words and sentences more or less grave, according to the diversity of places, times, matters, and persons he is speaking to or about.[26]

Daniele Barbaro, in his *Della eloquenza*, printed in Venice in 1557, imagines a dialogue between Nature, Art, and Spirit, in which Nature, speaking to Art, in one of its opening lines, says: "I recognize that your greatness consists in concealing yourself as much as you can, and in getting closer to me." This idea is then elucidated in terms that should sound familiar to us by now:

> Put effort into proving that your value derives from your nature rather than from your art, and you will be trusted as you always wanted to be. Speaking unstable words is a sign of truth, . . . alien to artifice, and being touched by the truth, correcting yourself,

crying out as you were enraptured by the truth, and finally show-
ing a diligent negligence and a negligent diligence, all of this can
give the appearance of truth.[27]

Also, in modern treatises on rhetoric we find the idea of *artem
celare*, often at the beginning, but always in a significant posi-
tion. In the first half of the eighteenth century, Charles Rollin
wrote: "[the ancients were very careful to] conceal arts, which in
fact ceases to be such, if patent, [a very different attitude in
comparison with] the ostentation and pomp of those writers
who seek nothing but to show their brilliance." Chaignet, in the
second half of the nineteenth century, wrote something similar:
"It is the natural which persuades, whereas artifice in composi-
tion or expression seems, when it is perceived, to be a snare, set
for the confidence of the hearer, who is indignant at this deceit
and feels a dissatisfaction which hinders persuasion."[28] More re-
cent works also echo this belief. C. Perelman and L. Olbrechts-
Tyteca discuss the theme of *dissimulatio* in section 96 of *The New
Rhetoric: A Treatise on Argumentation* (1958), remarking how "a
point emphasized by all the masters of style and the great ora-
tors [is that] the most effective eloquence is the eloquence that
appears to be the normal consequence of a situation." It is nec-
essary to react to the discrediting of discourse as a rhetorical
expedient and prevent it by adopting a number of precautions.
"Everything that proclaims talent is to be scrupulously avoided
if one wishes to avoid the dissociation [between the subject and
the rhetorical devices]. Nothing is more artificial—and neces-
sarily so, if one wants to master it—than the naturalness of
which the ancient writers speak so highly." In his manual *La
rhétorique* (1998), Olivier Reboul addresses from the very first
page the discrediting of rhetoric by saying that "in truth, the
rhetoric that gets blamed is the one that gets noticed, that is,

the one which misfires because either awkward or obsolete. True rhetoric is something else." The author later adds that "the key objective of oratory art is that of being overlooked. . . . The first rule of rhetoric is thus appearing sincere in the claim that one is not practicing any rhetoric."[29]

In all these examples, the art that must be concealed is the overall set of rhetorical techniques, its stock of codified procedures. But at the same time, the concealing art, the art aimed at dissimulation, is still a rhetorical art. The *dissimulatio* configures itself as a rhetorical device. As Seneca the Elder says, *pars est eloquentiae eloquentiam abscondere*:[30] the concealing of what is artificial is itself an artifice, the technique is fought with its own weapons. But at this point we are not yet in the position to solve the problem that arises precisely in this context, that is, the idea that if we really want to make sense of *artem celare*, as we shall see later on, *we need to cash out the meaning of the two occurrences of the term* ars.

It is thus extremely important not to conflate the position illustrated earlier with the refutation of rhetoric in the name of sincerity and naturalness, based on the firm belief that rhetorical ornaments are just snares and traps threatening the confidence of the listener, which sound argumentation should avoid. This is a very ancient conviction, as expressed by Euripides in a passage from *Phoenissae*:

> The words of truth are naturally simple
> and justice needs no subtle interpretations,
> for it has a fitness in itself; but the words of injustice,
> being sick in themselves, require clever treatment.[31]

This concept is familiar especially in modern times. Indeed, the strongest criticism of rhetoric, which was widespread at

the end of the eighteenth century and, thanks to Romanticism, remained uncontested for at least a century and a half, joined these reservations with those about discourses aimed at attracting the listener with means that were not natural, as is shown in Goethe's *Urfaust*, when Faust replies to the pedantic Wagner—who candidly said, "But good delivery can help the speaker's art"—with the following vehement words:

> Yes—in a puppet-show to speak his part.
> My learned friend, God help you then,
> Your foolishness will never end!
> Delivery counts for nothing when
> You say "I love you" to a friend.
> If with sincerity you speak,
> Why, then for words you need not seek.
> The dazzling rhetoric a speaker spins,
> The frills and flourishes with which he weaves
> His spell, are all as barren as the frosty winds
> That play among the arid autumn leaves.[32]

3

THE CONCEALED ORNAMENT

There is an important passage from Cicero's *Orator* that was intentionally omitted from the previous chapter. It reads:

> [The Orator] must take care, especially as he is allowed more license in these two, I mean the rounding of his periods, and the combination of his words; for those narrow and minute details are not to be dealt with carelessly. But there is such a thing as a diligent negligence; for as some women are said to be unadorned to whom that very want of ornament is becoming, so this refined sort of oratory is delightful even when unadorned. For in each case a result is produced that the thing appears more beautiful, though the cause is not apparent.[1]

This passage may not only be considered the origin of the "diligent negligence" oxymoron, which we have encountered in the previous chapters and will see again; it also raises, for the first time, a parallel between *rhetorical and cosmetic ornaments*. And this parallel introduces a different application of the *ars est celare artem* principle. The analogy between rhetorical and cosmetic

ornaments is quite old. In fact, it was employed by Plato in his *Gorgias* to criticize the art of rhetoric. Plato says that rhetoric is for the soul what cookery and *Kommotiké* (which refers to both cosmetics and dressing) are the for body: just as these are falsely believed to be substitutes for medicine and physical training, although they are nothing but surrogates for them (*Kommotiké*, in fact, "creates an illusion by the use of artificial adjuncts and make-up and depilatories and costume, and makes people assume a borrowed beauty to the neglect of the true beauty which is the product of training"),[2] rhetoric and sophistry are considered substitutes for legislation and justice, while, in fact, they are only their corruptions.

If one doesn't take the parallel as an argument against rhetoric per se, one may still use it to claim that, just as the best rhetorical device is the one that is most concealed, the best *maquillage* will be the less conspicuous one, and that even in the absence of makeup one can still be beautiful. Quintilian associated overflowered and studied eloquence with the made-up body, and well-balanced eloquence with the well-trained body: "Bodies that are in health, with the blood in a sound state, and strengthened by exercise, have their beauty from the same causes from which they have their vigor, for they are well-complexioned, of a proper tension, and with muscles fully developed; but if a person should render them artificially smooth, and paint and deck them in an effeminate fashion, they would be made eminently repulsive by the very labor bestowed in beautifying them."[3] Simplicity is appreciated in a speech as it is on a woman's face: "The *apheleia* of the Greeks, 'simplicity' pure and unaffected, carries with it a certain chaste ornament, such as is so much liked in women; and there is a certain pleasing delicacy of style that arises from a nicety of care about the propriety and significancy

of words."[4] Ovid also observes that a feigned carelessness can heighten beauty:

Et neglecta decet multas coma; saepe iacere
Hesternam credas; illa repexa modo est.
Ars casus similis.[5]

Art must simulate chance, and remain concealed (*ars faciem dissimulata iuvat*), Ovid writes a few lines later.[6] Horace's Pyrrha (*Odes*, 1.5) is *simplex munditiis*, that is, simple by virtue of her ornaments, deceiving her lovers with a studied naturalness.

No wonder, then, in Castiglione's *Courtier* there is an argument against "the pest of affectation" in which he praises *sprezzatura*, referring specifically to cosmetics: "Do you not see how much more grace a lady has who paints (if at all) so sparingly and so little, that whoever sees her is in doubt whether she be painted or not; than another lady so plastered that she seems to have put a mask upon her face and dares not laugh for fear of cracking it?"[7] The argument about unobtrusive makeup is also featured in Guazzo's *The Art of Conversation*, as he tries to defend cosmetics (and the women using them) against Annibal's criticisms:

Yet I must allow, that this art is not to be universally condemned, as not, in some cases, to be tolerated: for if it be lawful for a man to make use of a remedy to take away a wart, mole, spot, or other accidental blemish; much greater reason is there for a woman to be indulged, to correct, by art, any imperfection, either natural or casual, that may appear in her face. Therefore we will allow it lawful to a woman to redress any thing that is amiss about her, by art, if there is a necessity for it, either from some indisposition of her body, or for the conservation of her sex's honour; *provided*

it be done so slightly, and discreetly, that the artifice does not appear,
or if it does, that it give no distaste.[8]

The theme of studied negligence, or artificial naturalness, what Torquato Tasso once defined as "*bellezza in arte incolta*" ("beauty artfully unfostered"), is also present in *Jerusalem Delivered*. In the second *Canto*, the beautiful Sophronia displays a careless attitude toward her beauty, which she does not conceal or expose:

Non sai ben dir s'adorna o se negletta
se caso od arte il bel volto compose.
Di natura, d'amor, de' cieli amici
Le negligenze sue sono artifici.[9]

In the seventeenth century, Ben Jonson praised the kind of beauty that knows how to take advantage of "sweet neglect," while Robert Herrick spoke of "sweet disorder" and "wild civility" as more bewitching than "when art / Is too precise in every part":

Give me a look, give me a face
That makes simplicitie a grace;
Robes loosely flowing, hair as free;
Such sweet neglect more taketh me
Than all the adulteries of art;
They strike mine eyes, but not my heart.[10]

Similar ideas, but in their masculine variation, were endorsed in the nineteenth century by the iconic champion of dandyism, *Beau* Brummel. His idea of elegance pivoted on the principle of "not being eye-catching." Tying his knots required hours of preparation and many failed attempts, but all this care was in-

tended to give the impression that they were tied hastily and almost randomly.[11] About a certain twentieth-century dandy, namely, Drieu La Rochelle, François Mauriac said: "He's more than well-dressed, he's well badly-dressed."[12] In his *Treatise on Elegant Living*, Balzac writes: "Anything that aims at an effect is in bad taste." Perfection in dressing—as Baudelaire once said about dandies—consists in the utmost simplicity, which is also the best way to stand out when compared to others. Nonetheless, with respect to *maquillage* he maintains a thesis that is diametrically opposed to the one presented so far. In "In Praise of Make-Up" he writes, "Woman . . . must borrow, from all the arts, the means of rising above nature, in order the better to conquer the hearts and impress the minds of men. It matters very little that the ruse and the artifice be known of all, if their success is certain, and the effect always irresistible. . . . Make-up has no need of concealment, no need to avoid discovery; on the contrary, it can go in for display, if not with affectation, at least with a sort of ingenuousness."[13]

Obviously, just as virtuosity and the display of one's skills run counter to the concealment of art, one may oppose the dissimulation of cosmetics. This depends on one's personal preferences, and here I won't be addressing these kinds of preferences or their historical variations (the baroque and mannerism lean toward the ostentation of artifice, while classicism and romanticism lean toward its dissimulation). Rather, I am interested in focusing on how in this cosmetic widening of the principle of art concealing, which at first glance might appear to be a secondary and merely derivative application, a new conceptual connection finds expression, which allows us to appreciate an unexpected depth in *ars est celare artem*.

Let's take Cicero's example again: He claims that sometimes the very absence of ornaments is a kind of ornament itself.

A paradox awaits us here: beauty is understood as emerging from a "normal" condition that, in a sense, is the *presence* of ornament; therefore its absence is seen not so much as a *lack* of artifice, but rather as *an artifice of a different kind.* Alternatively, in Quintilian's comparison between healthy and well-trained bodies and beautified and made-up bodies, ornament is conceived as a mere insertion, an additional something that, by being superimposed, deteriorates what was already complete in the very attempt to refine it. However, following the latter opinion means irremediably heading toward the functionalist downplaying of ornament: only what has a function can be beautiful, while any ornament is unnecessary tinsel and, as Fénelon says, *chaque ornement qui n'est que ornement est de trop.*

This is neither Cicero's position in the *Orator* nor Castiglione's, who, in the *Coutier*, having already praised nonobtrusive makeup, writes:

> Again, how much more pleasing than all others is one (I mean not ill-favoured) who is plainly seen to have nothing on her face, although it be neither very white nor very red, but by nature a little pale and sometimes tinged with an honest flush from shame or other accident,—with hair artlessly unadorned and hardly confined, her gestures simple and free, without showing care or wish to be beautiful! This is that nonchalant (*sprezzata*) simplicity most pleasing to the eyes and minds of men, who are ever fearful of being deceived by art.[14]

In this case we are dealing with a faked simplicity, resulting from study and not from neglect. A beautiful smile is much appreciated, because, regarding teeth, "we may believe that less care is needed to make them beautiful than with the face"; however, those who look for every occasion to show them would

certainly give a very bad impression. "Yet if one were to laugh without cause and solely to display her teeth, she would betray her art, and, no matter how beautiful they were, they would seem most ungraceful to all." In these passages, as in Cicero's work, what gets expressed is the very impossibility of conceiving ornaments as things that can be added to the *natural* state that is identified with the absence of ornaments. If the absence of ornaments is itself an ornament, if it is possible, that is, to conceive *an ornament that does not appear*,[15] there is no possibility of having a *level zero*, something like "nonornament": simplicity can be affectation, and naturalness an artifice. This is true especially with respect to rhetoric. And it is a problem that still needs to be addressed by all those theories that depict rhetoric as a *deviation* with respect to a purely denotative, noncharacterized text. But does this kind of text even exist? How can one ever find it, if the absence of ornament is an ornament itself, and if the most unadorned speech can be incisive both from a literary and a rhetorical point of view? *A General Rhetoric* by the Groupe μ, a text written in the years of triumphant structuralism, is concerned with this problem: "We can also notice that the absence of a figure eventually creates a figure, that deviation might be constituted by the meaningful absence of deviation itself." However, a few pages later we read that "there can be no poetry without figures," and that the theory of style as deviation should still represent the grounding of the edifice of rhetoric, as if the previous assumption did not jeopardize the two presuppositions just mentioned.[16]

We should not be surprised, then, if this problem becomes pressing, especially in relation to contemporary art, as proven by the actual failure of virtually all more-or-less recent attempts to identify the formal evidence of the artistic value of, for example, literary works. The reasons for this failure are to be found

in the fact that in contemporary art the formal features of artistic value (think about, with respect to literature, figures of speech, the codified meters, and the like, though something similar can be said for visual arts as well) tend to play a much more diminished role than in the art of the past (for example, before the Romantic revolution). Art, all art, witnessed a parabolic movement, moving from the heavy use of formal devices as the index of artistic value to more sporadic employment of them. We might say that concealed art has gained in prominence when compared to displayed art, as the degree of conventionality in artistic works has progressively diminished.[17]

I will return to this point. For now, however, I would like to further complicate this argument. What has been said so far about art in which the visible artifice becomes less important than the concealed one is true, *but not completely so*, at least in the following sense: since ancient times concealed artifice has been considered potentially more important than that on display, and as playing a completely different conceptual role.

There is in fact at least one ancient text in which this idea is fully expressed, namely, *On the Sublime* by Pseudo-Longinus. This is an anonymous text, probably composed in the first century AD.[18]

Pseudo-Longinus introduces the theme of *artem celare* for reasons that by now should sound familiar, that is, the traditional reasons of rhetoric:

> There is an inevitable suspicion attaching to the sophisticated use of figures. It gives a suggestion of treachery, craft, fallacy, especially when your speech is addressed to a judge with absolute authority, or still more to a despot, a king, or a ruler in high place. He is promptly indignant that he is being treated like a silly child and outwitted by the figures of a skilled speaker. Construing the

fallacy as a personal affront, he sometimes turns downright sav-
age; and even if he controls his feelings, he becomes conditioned
against being persuaded by the speech. So we find that a figure
is always most effective when it conceals the very fact of its being
a figure.[19]

The reference to forensic rhetoric and the argument about
the suspicion of treachery are perfectly coherent with the rea-
sons usually given in favor of *dissimulatio artis.* But toward the
end of the quotation, it becomes clear that the anonymous au-
thor had in mind a deeper explanation for the paradoxical con-
clusion that what at first sight might be thought of as created
precisely in order to be noticed, that is, the figure, must remain
concealed instead. The reason why it is necessary to conceal art
lies indeed in the peculiar relation between the sublime and the
various figures at play: "Sublimity and emotional intensity are a
wonderfully helpful antidote against the suspicion that accom-
panies the use of figures. The artfulness of the trick is no longer
obvious in its brilliant setting of beauty and grandeur, and thus
avoids all suspicion." The sublime makes use of the figures, which
are to some extent required by it, but the sublime does not *con-
sist* in the figures, as Pseudo-Longinus's conception of the sub-
lime does not correspond to the sublime or elevated *style* of
rhetoric, but rather is considered to be more than merely a for-
mal quality of literary works.

This is the first occurrence of what will be a leitmotif in my
narration, which will appear again in the following chapters
that address more recent centuries. What is at stake here are
not only the nontechnical roots of the sublime (that is, pathos
or emotional intensity), but also what we moderns might char-
acterize as an aesthetical value, which is not (only) created by
means of a sublime style.[20] It is in fact possible to consider as

sublime even those expressions that are or appear to be absolutely simple and plain, *literal*, like the biblical "And there was light," quoted by Longinus, or familiar, ordinary, common expressions.[21]

How does a figure conceal itself? "By its very brilliance," Longinus answers:

> Much in the same way that dimmer lights vanish in the surrounding radiance of the sun, so an all-embracing atmosphere of grandeur obscures the rhetorical devices. We see something of the same kind in painting. Though the highlights and shadows lie side by side in the same plane, yet the highlights spring to the eye and seem not only to stand out but to be actually much nearer. So it is in writing. What is sublime and moving lies nearer to our hearts, and thus, partly from a natural affinity, partly from brilliance of effect, it always strikes the eye long before the figures, thus throwing their art into the shade and keeping it hidden as it were under a bushel.[22]

Pseudo-Longinus thinks that it is impossible to intertwine expressive efficacy with various technical procedures; rather, expressive efficacy must always depend, so to speak, on a different assessment than rhetorical technique, and this assessment can vary according to circumstances. In this picture affectation is to be spurned. But, we might ask, what exactly is affectation here? It is the mistake, typically made by young or inexpert persons, of thinking that the more extraordinary and "artistic" the language of a literary work, the more incisive it is.[23] But, instead of trying to be effective at any cost, we should never lose sense of proportion and limit (*metron*). The opportune moment, the *kairos*, operates here as a court of last instance: an accumulation of metaphors, for example, might not sound affected if justified by an overflow of passions.[24]

Demetrius—in the treatise on style attributed to him, another work of uncertain dating, but probably composed in the third century or second century BC (therefore much older than Longinus's)—disapproves of the *cacozelon*, or *mala adfectatio* (bad affectation).[25] The principle of *artem celare* is explicitly evoked by Demetrius:

> Do not, however, crowd figures together. That is tasteless and suggests an uneven style. The early writers, it is true, use many figures in their works, but they position them so skillfully that they seem less unusual that those who avoid figures altogether.[26]

Demetrius dwells a great deal on what he calls *logos eschematisménos*, a *sermo figuratus* in the narrow sense: the kind of speech that—when one wants to blame or advise a powerful man—diplomatically appeals to dissimulation, and that, with tact and prudence, ensures that reproaches and exhortations do not appear to be what they really are.[27]

Going back to Longinus's *On the Sublime*, it may be noticed that the general principle of art concealment is invoked with regard to some particular rhetorical figures. For example, "the best hyperbole is that which does not seem to be an hyperbole." There are also figures, such as that of the hyperbaton, that seem particularly suited to dispel the suspicion of artificiality:

> The figure consists in arranging words and thoughts out of the natural sequence, and is, as it were, the truest mark of vehement emotion. . . . The use of hyperbata allows imitation to approach the effects of nature. For art is only perfect when it looks like nature and nature succeeds only when she conceals art.[28]

In this quotation a word reverberates that is new to our discussion, though we did have a glimpse of it, or at least suspected

its presence, namely, *nature*. *Sprezzatura*, which is the opposite of affectation, is a kind of naturalness. Castiglione's courtesan must be able to talk "with that simple candour that makes it seem as if nature herself were speaking."[29] The art that conceals itself presents itself as nature. Longinus's aforementioned principle will recur in very similar wording in Kant's *Critique of Judgment*, where we can read, "Nature was beautiful, if at the same time it looked like art; and art can only be called beautiful if we are aware that it is art and yet it looks to us like nature."[30] We shall return to this point. For now, what do we mean by *nature*?

No word is perhaps more polysemic, and *nature*, of course, also has many different meanings in aesthetic discourse: the father of the history of ideas, Arthur Lovejoy, distinguished in the seventeenth and eighteenth centuries alone no less than eighteen meanings of "nature."[31] The kind of naturalness opposed to affectation surely is not naturalness in the sense of naïvety; rather, it results from study and exercise: when the courtier plays some music—as Castiglione says—"although he may know and understand that which he is doing, in this too I would have him hide the study and pains that are necessary in everything one would do well, and seem to value this accomplishment lightly in himself, but by practicing it admirably make others value it highly."[32] *What we have here is, as it were, a second-ordered nature, obtained by what is distinct from and opposed to nature.* We will encounter this crucial distinction again in chapter 8, wonderfully expressed in a passage by Leopardi. On the other hand, it cannot be said that the kind of naturalness we are looking for is *in every sense* something merely artificial, conscious and available ad libitum. No wonder, then, nature is contiguous to *grace*, which is something that cannot be fully learned. One can't be graceful *on purpose*, nor can one be *sprezzato* or sublime. It is in the very attempt to look graceful that one turns out to be affected

and mannered. To mention the whirling image used by Heinrich von Kleist in "On the Marionette Theatre," grace consists in that naturalness achieved "when knowledge has as it were gone through an infinity."[33] Otherwise, to borrow Jon Elster's words, themselves profitably employed to characterize aesthetic behavior by Stefano Velotti in a recent book of his, we might define grace or *sprezzatura* as those *states that are essentially by-products*, in this resembling forgetfulness—one cannot in fact forget something by deciding to forget it, as she would run the risk of remembering it even more. According to Guez de Balzac, grace resembles *urbanité*: the more one strives for it, the more one is on the verge of losing it. Perelman and Tyteca, in *The New Rhetoric*, write that grace is like "those actions which have an effect only when they were not carried out to achieve this effect."[34]

Moreover, naturalness is not only *on the part of the artist*; it is, as it were, also on the part of the work, that is to say that the more the work resembles a natural product, the more it looks perfect. And here we turn to one of the most famous occurrences of the phrase *ars est celare artem*, an occurrence so famous that, misleadingly, it is thought to be the origin of all the others. We find it in Ovid's *Metamorphoses*, in the famous episode of Pygmalion. Pygmalion, outraged by Propoetides's immorality and corruption, lives alone and, *mira feliciter arte*, carves the figure of a woman in white ivory, giving it a beauty possessed by no real woman. It has the face of a true maiden, whom one may believe is alive and about to move, so much so that the sculptor hides his own art. *Ars adeo latet arte sua*: by concealing itself, art creates a work that seems the perfect fruit of nature, leading Pygmalion to fall in love with it until Aphrodite, granting his wish, makes it come alive.[35]

4

ART OR NATURE?

Ovid's lines on Pygmalion take us from rhetoric to sculpture. As we move into the visual arts we can pick up the thread from Castiglione's *Courtier*. I have mentioned two routes that depart from the *Courtier*, and have so far followed the one rooted in ancient oratory. However, Castiglione gives us another extremely fertile clue in his narrative: "It is said also to have been proverbial among some very excellent painters of antiquity, that over diligence is harmful, and Protogenes is said to have been censured by Apelles because he did not know when to take his hand from the tablet."[1]

The source in this case is certainly Pliny's *Naturalis Historia*, if we recall the passage about *grace* in the book 35 partially quoted earlier. The complete passage runs as follows:

> His art was unrivalled for graceful charm, although other very great painters were his contemporaries. Although he admired their works and gave high praise to all of them, he used to say that they lacked the glamour that his work possessed, the quality denoted by the Greek word charis, and that although they had every other merit, in that alone no one was his rival. He also asserted another claim to distinction when he expressed his admiration

for the immensely laborious and infinitely meticulous work of Protogenes; for he said that in all respects his achievements and those of Protogenes were on a level, or those of Protogenes were superior, but that in one respect he stood higher: that he knew when to take his hand away from a picture as noteworthy warning of the frequently evil effects of excessive diligence.[2]

In this *nimia diligentia* we can immediately recognize Castiglione's *affettazione* (affectation); the author of *The Book of Courtier*, for his part, was well aware of the renowned anecdote about Apelles featured in Cicero's *Orator*: "In every case it is necessary to take care how far it may be right to go, for although everything has its proper limit, still excess offends more than falling short. And that is the point in which Apelles said that those painters made a blunder, who did not know what was enough [*eos peccare dicebat, qui non sentirent quid esset satis*]."[3]

It not surprising, then, to find in Castiglione a connection between the rhetorical and the visual arts, for to a certain extent this connection was already in place in classic sources. Moreover, Apelles's maxim has been used as a warning about the danger of an excess of care, for example, in Leon Battista Alberti's *De pictura*:

> But it is best to avoid the vitiating effect of those who wish to eliminate every weakness and make everything too polished. In their hands the work becomes old and squeezed dry before it is finished. The ancient painter Protogenes was criticized because he did not know how to raise his hand from his panel. He deserves this, because it seems to me a bizarre act of stubbornness, not one of an intelligent man. It is well to exert ourselves as much as our intellect is capable to see that by our diligence things are done well. To wish that they be more than appropriate in every

respect is not possible. Therefore, give to things a moderated diligence and take the advice of friends.[4]

Or also in Lorenzo Ghiberti's *Commentarii*:

[Apelles] said that [Protogenes] was in all respects equal or superior to him, but claimed to be better in this, that he was not able to stop his hand, with remarkable insight; very often too much diligence is harmful.[5]

It is interesting to notice how the idea that overaccurate execution compromises the work of art becomes commonplace in sixteenth-century treatises on art, and that its origins are the *Courtier*. Lodovico Dolce's works are crucial for the rapid diffusion of *artem celare*. He in fact edited several editions of the *Courtier*,[6] and wrote, among other works, a dialogue on painting called *L'Aretino*, printed in 1557. The dialogue starts by drawing an opposition between Fabrini, a strong supporter of Michelangelo's excellence among other painters, and Aretin, who on the contrary denies Michelangelo's superiority. In the first pages in particular, they discuss Raphael's art. At stake is the opposition, destined to become canonical, between Michelangelo's *terribleness* (today we would perhaps say *sublimity*) and Raphael's *grace*, that is, between the latter's *maniera facile* (easy or gentle manner) and the former's *maniera difficile* (difficult or hard manner):

I know that at Rome, while Raphael was living, the learned and the most skillful artists there preferred him to Michael Angelo as a painter, and that those who held him inferior were for the most part sculptors, who considered only Michael Angelo's excellence in design and the forcible air of his figures; esteeming the graceful and gentle manner of Raphael too easy, and consequently not so artificial; not knowing that ease is the highest

accomplishment of any art, and the most difficult to be attained; *that hiding art is the utmost extent of art.*[7]

Dolce also uses the term *sprezzatura*:

FABRINI: It appears to me, that in this a certain negligence [*sprezzatura*] is necessary, so that there may not be too studied a beauty of colouring, nor the figures too highly finished, but an agreeable temperance throughout. For there are some painters who finish their figures so very highly, that they appear painted and with such exact dresses of the hair, that not a single one is out of its place. This is a fault, not a beauty; because it gives into affectation, which deprives every thing of grace. Whence the judicious Petrarch, speaking of the hair of his Laura, says "*Negletto ad arte, innanellato, ed irto.*" . . .

ARETIN: It is above all things necessary to avoid too scrupulous diligence, which is hurtful in every work of art [here follows the renown anecdote on Apelles and Protogenes]. . . .

FABRINI: This superabundant diligence is equally hurtful to writers; for wherever labour is discoverable, there necessarily is hardness and affectation, which is always wearisome to the reader.[8]

Dolce's anti-michelangeloesque position, even though it ascribes to Raphael the ability to make his incredible skills seem "natural," should not distract us from the fact that Michelangelo endorsed the precept of art concealment too, at least according to Francisco de Hollanda and Giovan Battista Gelli. The former, in his *Dialoghi Romani*, reports the following statement, which is said to be Michelangelo's:

I'd like to tell you, Mr. Francesco de Hollanda, the biggest quality of our art, which perhaps you would know well, and whose utmost perfection I think you esteem, that is, the hardest thing

in a pictorial work of art, is that of producing it with the utmost care and skill, so that after being worked for long, it seems to be executed almost in a rush, without any pain and rather quite lightly, though it's quite the opposite. This is a great maxim and utmost perfection. And it sometimes happens, though quite rarely, that a work of art executed with little effort is successful in this way; and it is actually more common to realize it by strokes of effort, yet appearing as an effortless result.[9]

Gelli confirms: "As our Michelangelo Buonarroti used to say, the only good figures [are] those devoid of any effort, that is, produced with such skillful art, [so] that they appeared as natural rather than artificial."[10]

It is evident that a troubled artist such as Michelangelo wants to stress that the ease in execution shown by the artist often conceals sustained efforts (*"Io nell'opere mie caco sangue"*). But, at the same time, it is easy to see how these words might suggest a simplification of the principle of *art concealment*, fostered primarily by the reduction of *sprezzatura* to the *rapidity* of execution. This is clearly appreciable in De Hollanda, who places the aforementioned passage right after one where he ascribes to Michelangelo a sort of praise of rapidity, which runs as follows: "I can tell you that to realize a work of art with great quickness and skillfulness is convenient and advantageous; and to be able to accomplish in a few hours what others take many days to paint is a precious gift from the Almighty God. . . . So that the artist who, though rushing her work, paints as the artist working slowly deserves the greatest praise."

But if the *appearance* of naturalness and ease gets confused with naturalness tout court, that is, with the absence of premeditation and study, the paradoxical character of the concept of *facilitas difficilis* gets lost, together with the peculiarity of the

principle of "art concealment." This would pave the way for an apology of mere spontaneity and easiness: *naturalness would not then be understood as the ultimate result of artifice, and considered as such artificial and studied, but it would rather become the very antithesis of artifice.* This is a crucial point that marks a divide between two different conceptions of *artem celare.* By glossing over the *as if* (art should seem easy, *as if* it were a natural product), we shall eventually end up praising mere spontaneity and immediacy as the true principles of art—something closer to Romantic poetics, or, better, to its vulgate, than to the theories addressed here.

It would certainly be a bit of a stretch to consider Giorgio Vasari a forerunner of a conception of art as purely spontaneous expression, or a precursor to Romantic ideas about the genius-creator, even if some influential commentator has offered precisely such a reconstruction.[11] When, in the preface to part 3 of his *Lives*, Vasari introduces the concept of *grace*, he seems inclined to somehow preserve its paradoxical status. He writes that fifteenth-century authors never reached perfection in their works because

> they still lacked, within the boundaries of the rules, a freedom which—not being part of the rules—was nevertheless ordained by the rules and which could coexist with order without causing confusion or spoiling it. . . . In proportion, they lacked good judgement which, without measuring the figures, would bestow upon them, no matter what their dimensions, a grace that goes beyond proportion. In design they did not reach the ultimate goal, for even when they made a rounded arm or a straight leg, they had not fully examined how to depict the muscles with that soft and graceful facility which is partially seen and partially concealed in the flesh of living things, and their figures were crude and clumsy, offensive to the eye and harsh in style.[12]

However, in Vasari the warning against *nimia diligentia* (what he calls "diligent efforts" and "study" that "[produce] a dryness of style") turns into a praise of easiness. Thus, in the "Description" of his works at the end of the *Lives*, he writes: "this, indeed, I will say, because I can say it with truth, that I have always executed my pictures, inventions, and designs, whatever may be their value, I do not say only with the greatest possible rapidity, but also with incredible facility and without effort."[13] Even if Vasari, speaking of Michelangelo, talks about a "difficult style, which he puts into practice with such great facility," and cites the *artem celare* in the life of Piero di Cosimo, though in antiphrasis ("He gave his attention to colouring in oils, having seen some works of Leonardo's, executed with that gradation of colour, and finished with that extraordinary diligence, which Leonardo used to employ when he wished to display his art"), it is clear that for him facility is a value in itself, which can be opposed to *study*, as illustrated by the life of Paolo Uccello:

> There is no doubt that anyone who does violence to his nature with fanatical study may well sharpen one corner of his mind, but nothing that he creates will ever appear to have been done with the natural ease and grace of those who place each brush-stroke in its proper place and . . . avoid certain subtleties which soon encumber their works with an overworked, difficult, arid, and ill-conceived style.

Or rather exalted as a gift from God, as in the life of Desiderio da Settignano:

> Very great is the obligation that is owed to Heaven and to Nature by those who bring their works to birth without effort and with a certain grace. . . . And this springs from facility in the production of the good, which presents no crudeness or harshness to the

eye, such as is often shown by works wrought with labour and difficulty.[14]

But if we are to see preserved the ambiguous character of *sprezzatura* we need to look elsewhere, for example, in Gregorio Comanini's much less famous treatise, published in 1591, *The Figino, or On the Purpose of Painting*. Comanini addresses the notion of *sprezzatura* in a discussion about the contiguity between painting and poetry, following the Horacian tradition of *ut pictura poësis*:

> As the poet plays with antitheses, or opposites, the painter counterbalances the figures of women with those of men, of children with those of the aged, ocean bays with the earth, and valleys with mountains in a single painting. These and other similar contrasts in painting are no less appealing than those arising from the contraries in a good poem. It is wonderful to consider how the painter's appeal equals that of the poet in such matters. In a serious composition he avoids matching contrapposto with *contrapposto*, but with an artful carelessness, in order to counterbalance the previous words, he adds one that has nothing corresponding to it above, since he knows that these antitheses breed commonness and lowness, and do not suit a magnificent type of style.[15]

In 1590, the year before the publication of *The Figino*, appeared Giovan Paolo Lomazzo's *The Idea of Temple of Painting*, in which we find again the Plinian judgment about those painters who "work even harder when given completely to imitating others, for they understand nothing of their own nature from which derive all the facility and grace in work. They never know when to lift their hand from a painting nor when to stop polishing their work, producing, in the end, what they themselves

perceive and admit to be without any force." But, most importantly, we also find a neat formulation of our principle:

> Artists must contrive to make all the parts appear to have no knowledge of art, that is, their works must not seem made after precepts, since the worst artistic fault is to show art in art. On the contrary, they must attempt to show that, in art, there is no art, only nature herself, as Apelles among the ancients tried painstakingly to demonstrate.[16]

From the Italian art treatises of Cinquecento, then, the principle of the concealment of art passes through European treatises: for instance, in Franciscus Junius's *The Painting of the Ancients*, published in 1637, we find yet another clear reformulation of the principle:

> We are therefore above all things to take good heed that there do not appear in our works a laborious gayness and over-curious affectation of grace; since it is most certaine that such a poore and filly affectation of finesse doth but weaken and break the generous endavours of a thoroughly heated spirit. This not far fetched are always best; because they do not best agree with the simplicitie and Truth of Nature. Whatsoever doth on the contrary bewray an excessive care and studie, can never be gracefull and comely; because it dazleth our senses. . . . As in many other Arts the main strength of Art doth principally consists in the warie concealment of Art; so doth the chief force and power of the *Art of painting* especially consists therein, that it may seem no Art.[17]

This principle is still quite present in the Italian literature. For example, we find *Sprezzo* and *sprezzatura* in Pietro da Cortona, in Ridolfi, and in Boschini's *Carta del navegar pitoresco*.[18]

In Francesco Scannelli's *Microcosmo della pittura* (1657) we also find a direct reference to Castiglione's *Courtier*:

> The works of the great Masters are those that show us better than others many features, among which that *sprezzatura*. . . . We can say with the already-mentioned Castiglione that true art is that which contains all in the maximum degree, without showing off.[19]

Giovan Pietro Bellori, in his *The Lives of Modern Painters, Sculptors, and Architects* attributes the following to Caravaggio:

> He professed, moreover, to be so faithful to the model that he would not claim so much as a single brushstroke as his own, saying that it belonged not to him but to nature; and scorning every other rule, he considered it in the height of artistry to owe nothing to art.[20]

In the eighteenth century, the principle of *ars est celare artem* is particularly appreciated in the neoclassical environment. The Count of Caylus praises what he calls *légerté de l'outil*:

> The lightness of the tool should not exceed the surface . . . [and] it is the last touch that imparts the utmost impression in the spectator, that seduces her. . . . It is composed of those neglected things that can only be compared to what is alluded to, to those suspended words constituting the grace of the conversation; one can feel them, not define them. . . . The genius acts confidently and expresses herself without difficulty in order to mask or conceal the efforts and difficulties overcome to get there.[21]

Raphael Mengs, a Bohemian painter fated to have brilliant success in Italy and Spain, in his *Pensieri sulla bellezza e sul gusto*

nella pittura, written in close contact with Winckelmann in Rome and published in Switzerland in 1762, says: "The paintings which are commonly praised, and esteemed of good taste, are those in which one sees well expressed the principal objects, with a certain ease, which hides all labour and art."[22] A relatively unknown scholar from Rome, probably of Mengs's acquaintance, namely, Giuseppe Spalletti, who wrote *Saggio sopra la bellezza* in 1765, which had some circulation in Europe, praises the *Semplicità difficilissima*:

> It is, however, not untrue in the end that the object appearing as most simple to the soul does not seem to be shaped by art. The delicate *sprezzatura*, extremely difficult also to the great minds, is only apparent to those well navigated into art, who will find this work beautiful, and for this reason they will praise it, because they would deem the skill employed by the author as in line with those rules, which are recognized by those mastering the art. And only the latter will be able to account for this experience, and establish the precision involved in its performance, so that in the work in which art has exhausted itself, no skill will be visible. . . . Simplicity in all things is highly praised; but in order to achieve it, one should be extremely skilled and astute.[23]

In the same year, the great sculptor Etienne-Maurice Falconet expressed similar thoughts. In the *Réflexions sur la sculpture* he writes about his own art:

> Sculptural art is above all the enemy of those forced behaviors that nature disowns . . . she is the enemy of those draperies whose richness lies in its superfluous decorations . . . as it is of the too-polished contrasts sought after in the contrived composition and display of the forms. . . . The more evident the efforts

to touch us, the lesser we are; because of this it is necessary to conclude that the less the means employed to produce a certain effect, the more she is deserved and the more the audience will be happy to form the impression the artist wanted to induce.[24]

Less is more, then: this could well be a neoclassical motto, or at least this is the opinion of its principal Italian theorist, namely, Francesco Milizia: "we still have to address the principle according to which we should obtain the most possible with the least possible? A composition might be rich in figures and lacking in ideas. The contrary is unlikely indeed, as it requires a lot of application and skills to make each different piece equally beautiful. . . . In certain situations one can sometimes make use of some negligence, in order to make the primary subject stand out; but it takes an art to be negligent."[25] In a letter of 1787 Milizia again expresses this idea when he writes about the mausoleum of Pope Clement XIV in Santi Apostoli in Rome: "the composition has the character of simplicity, which resembles simplicity itself though in truth it is the essence of difficulty,"[26] while in the *Dizionario delle belle arti e del disegno* we find the entry *stento* followed by the statement "the artist won't be appreciated, if she will display the struggle involved in crafting her work."

The understanding of *artem celare* in terms of simplicity, moderation, and sacrifice is certainly functioning in neoclassical theories, but in those recurring and quite generic readings we can see that our paradoxical principle changes, suddenly becoming commonplace. And indeed it shall become quite a widespread commonplace in the new season of thought, so much that we encounter it even in proverbially antithetic painters like Ingres, who writes that "art reaches its highest degree of perfection when it resembles nature so perfectly that it can be mistaken with it. Art is at its best when concealed," and Delacroix, who

claims that "Titian is the greatest painter because he reveals his art the least,"[27] or in very different critics like Stendhal, who argues that "such is then the peculiarity of the human heart. In order for works of art to be absolutely delightful, they should hide every effort in the making. The human soul, in savoring the charm of a painting, sympathizes with the artist. But once it notices the effort behind it, the divine spell is lost. . . . A certain apparent carelessness adds charm to grace,"[28] and Ruskin, who in *Modern Painters* writes:

> The skill of the artist, and the perfection of his art, are never proved until both are forgotten. The artist has done nothing till he has concealed himself,—the art is imperfect which is visible,— the feelings are but feebly touched, if they permit us to reason on the methods of their excitement. . . . It is far more difficult to be simple than to be complicated; far more difficult to sacrifice skill and cease exertion in the proper place, than to expend both indiscriminately.[29]

To find more substantial discussions and theoretical developments on the *artem celare* we have to move away from painting, leaving aside its metaphorical nature, and address real nature. We need to, so to speak, go out into the garden.

5

IN THE GARDEN

I n 1792 the poet Ippolito Pindemonte presented an essay ti-
tled "Dissertazione su i giardini inglesi e sul merito in ciò
dell'Italia" ("Dissertation on English Gardens and on the
Merits of Italy in Them") to the Academy of Science, Litera-
ture, and Arts in Padua. Pindemonte addressed the new kind of
garden that had became popular throughout England in the
first half of the eighteenth century as a reaction to the geomet-
rical, regular, and architectural designs that were typical of
Italian gardens (since the fifteenth and sixteenth centuries) and
French gardens (*les jardins du grand siècle*, such as those in Ver-
sailles). The new designs replaced linear flowerbeds, flowered
parterres, gravel paths, topiary, sculpted plants, and fountains
with free ground undulations, green grass, random groups of
trees, free-flowing watercourses, and small lakes. In the rest of
Europe, however, this kind of garden took hold slowly, and
only at the end of the eighteenth century did it grow popular in
Italy. Pindemonte's essay is the first of a number of works that
discusses this phenomenon, among them pieces by Luigi Mabil,
Melchiorre Cesarotti, and Vincenzo Malacarne, which would
later be included in the collection *Operette di varj autori intorno
ai giardini inglesi ossia moderni* (*Short Essays of Various Authors on*

English or Modern Gardens) that was published in Verona in 1817.[1]

At the beginning of his piece, Pindemonte didn't seem to question the *English* origin of the new landscape sensibility, certified, as it were, by the very name—English Garden—by which the new gardens were called, a name destined to last, replacing, at least in ordinary parlance, other, more descriptive denominations like *picturesque, informal,* or *landscape garden.* Pindemonte began by quoting Francis Bacon's *Of Gardens,* the incunabulum of the new taste, and seemed inclined to admit that, even if Renaissance Italy had a primary role in the renewed interest in gardens, as well as in the arts and literature, now such merit is completely undeserved: "We should admit that nowadays many nations surpass us in the love and care of such tranquil and sophisticated luxuries, and that England masters them above all nations."[2]

In the concluding section, however, Pindemonte returned to the question of the origin of the modern garden, but this time he proposed a very different account of its genealogy. He rejects the theory that the new taste for irregular gardens originated in the East, precisely in China, and seemed skeptical about the descriptions of Chinese gardens presented by William Chambers in *A Dissertation on Oriental Gardening*; furthermore, he affirmed that nothing about the ancients anticipated the English garden (Alcinous's garden was just a vegetable garden), and that Italian gardens had been regular or geometrical since the fourteenth century. At the same time, though, he declared his unwillingness to follow Horace Walpole's essay *On Modern Gardening* in considering John Milton, with his famous description of the Eden in book 4 of *Paradise Lost,* as the literary archetype of the new garden. According to Pindemonte, another name should be invoked in this respect, and that is the name of

an Italian poet who lived one century before Milton, namely, Torquato Tasso: "With the strength of his genius alone, he was the first to have the idea of such gardens."[3]

To argue this point, Pindemonte considered Milton's description of Eden, in Paolo Rolli's translation, together with the octave in canto 16 of *Jerusalem Delivered*, in which Tasso describes the garden of Armida:

> When they had passed all those troubled ways,
> The garden sweet spread forth her green to show,
> The moving crystal from the fountains plays,
> Fair trees, high plants, strange herbs and flowerets new,
> Sunshiny hills, dales hid from Phœbus' rays,
> Groves, arbors, mossy caves, at once they view,
> And that which beauty most, most wonder brought,
> Nowhere appeared the art which all this wrought.[4]

"Nowhere appeared the art which all this wrought": in Pindemonte's view, this well-known ending line contains the very essence of landscape gardens: "the octave is finally closed by the definition, one might say, of the English garden, *in which is sought above all that art, which all this wrought, without appearing.*" Indeed, he could have equally cited his own definition of picturesque gardening from the beginning of his address: "the art of the English gardener consists in decorating a pretty vast field, in a way in which nature itself might have done." As for Tasso's subsequent lines, "So with the rude the polished mingled was, / that natural seemed all, and every part; / *Nature* would craft in counterfeiting pass / and imitate her imitator, *Art*,"[5] Pindemonte observes that they clarify the concept "with ever more precision," which, however, given their recondite character, is scarcely credible. Tasso wants to suggest that the garden of

Armida seems to be working under the spell of an artifice that is a product of nature itself, amused by the imitation of human art, which, in turn, is usually conceived as the imitation of nature. Nonetheless, Pindemonte reads those lines as perfectly in agreement with his interpretation, because they echo almost literally the description of the English garden given by one of the first theorists of the new taste, namely, William Shenstone, who writes, "Where some artificial beauties are so dexterously managed that one cannot but conceive them natural, some natural ones so extremely fortunate that one is ready to swear they are artificial."[6] Pindemonte firmly believes that Milton heavily borrowed from Tasso, and the lines quoted by him are almost indisputable evidence of the fact that the Italian poet is the father of the *English* garden: "It seems to me the picture of the English garden is expressed in the quoted verses with complete clarity, inducing us to conclude that Tasso was the inventor of this genre, a genre that neither the gardens of his time, all symmetrical in style, nor the descriptions of the ancients could have suggested to him."[7]

Pindemonte's thesis about the Italian origin of landscape gardens and about Tasso's connection to it has been reprised by more than one contemporary author. In particular, it has been endorsed by the influential critic Mario Praz, who, in *Armida's Garden*, writes: "Tasso's application of the idea of comely negligence to the garden had far-reaching consequences. . . . Tasso made a first step towards the creation of the 'natural' or picturesque garden that became an English specialty during the eighteenth century. . . . The earliest idea of the landscape garden in Europe can be traced to him."[8] More recent studies have rejected this hasty historiographical theory.[9] According to them, not only is it difficult to understand the thought patterns and actual circumstances that could have led Tasso to originate a

phenomenon as complex as the new garden, which was the result of many cultural factors, but it also seems hardly possible, if not a deliberate anachronism, to read the landscape garden in the eighteenth-century sense of the term into the Tassonian description.

Tasso's garden is indeed manneristic (like those of Bomarzo or Pratolino, for example), hence distant from the geometrical and standard character of the traditional Italian garden. It aims, however, at a *natura artificiosa* (artificial nature), which is completely different from the wild and spontaneous nature of the English garden. More precisely, Tasso's garden has much in common with the "third nature" theorized by some sixteenth-century garden experts, such as Alberto Lollio ("nature, incorporated into art, becomes creator and connatural of art, and together they create a third nature, in lack of a better name").[10] In this respect, Tasso's letter to G. Botero quoted by Pindemonte in the appendix to his essay is relevant. In it, the poet found in the so-called Parco Vecchio in Turin—a park wanted by Charles Emmanuel I of Savoy—the source of inspiration for his garden of Armida, and it not only is apocryphal, as maintained by some commentators, but probably proves the opposite of what both Pindemonte and Praz believe. That park, which was destroyed at a later stage, was in fact precisely a manneristic garden, and certainly not an English garden ante litteram.[11]

Once the truth about the history of gardens is established, we need to address the role played by the principle of *ars est celare artem* in the poetics of landscape gardening and in the invention of English parks. From this point of view, it is not of great importance whether or not eighteenth-century theorists borrowed the idea of the concealment of art from Tasso (this could not be excluded a priori). In light of what has been claimed in previous chapters, it should be clear that in the eighteenth

century this idea reached England and Europe via many different, but not unusual, routes, starting, as we know, from Longinus's treatise, which was enthusiastically read from the seventeenth century on, especially across the Channel. Rather, it is important to verify if and how *artem celare* and its related problems are present in eighteenth- and nineteenth-century writings on gardens.

In this regard, we have too many choices. There are so many references, often absolutely explicit, to the principle of *ars est celare artem* that we run the risk of missing many of them. In one of the articles from the *Spectator* in the text from 1712 known as "Pleasures of the Imagination," Joseph Addison expresses his views against architectonic and geometrical gardens, which at that time were prevalent in Europe and in England as well: "Our Trees rise in Cones, Globes, and Pyramids. We see the Marks of the Scissors upon every Plant and Bush. I do not know whether I am singular in my Opinion, but, for my own part, I would rather look upon a Tree in all its Luxuriancy and Diffusion of Boughs and Branches, than when it is thus cut and trimmed into a Mathematical Figure." And then, in order to confirm his belief, he draws fully from William Temple's *Upon the Gardens of Epicurus*, written some twenty years before, in which there is a reference to the Chinese predilection for irregular gardens: "Writers who have given us an Account of China, tell us the Inhabitants of that Country laugh at the Plantations of our Europeans, which are laid out by the Rule and Line; because, they say, any one may place Trees in equal Rows and uniform Figures. They choose rather to show a Genius in Works of this Nature, and *therefore always conceal the Art by which they direct themselves.*"[12]

A few years later, in 1728, Alexander Pope, who, on his Twickenham property, created one of the first examples of a landscape

garden, which later also became an unmissable destination for many pilgrimages, wrote:

> In all, let Nature never be forgot,
> But treat the goddess like a modest fair,
> Not over dress, not leave her wholly bare
> Let not each Beauty ev'ry where be spied,
> Where half the skill is decently to hide.
> He gains all points, who pleasingly confounds,
> Surprises, varies, and conceals the bounds.[13]

Here we simply cannot avoid the comparison between a kind of beauty that must not always be visible (since half the skill consists in "decently hid[ing]") and the precepts on poetics described by Pope himself in his very influential *Essay on Criticism*:

> That art is best that most resembles her [Nature]
> Which still presides, yet never does appear.

That these references to *artem celare* are not accidental is demonstrated by the several recurrences of this theme in one of the most systematic and incisive studies about the formation of the new sensibility, namely, Horace Walpole's *Of Modern Gardening*, first published in 1771 and reprinted many times since. Walpole, talking about William Kent, who was among the principal propagators of the new taste for landscapes, praises him for having removed "the artificiality of art" from gardening. In Walpole's opinion, Kent understood that all nature is a garden, and that "the modern gardener *exerts his talents to conceal his art.*" Walpole also believes that those European continental countries that borrowed the English model tended to distort the founding principles of modern gardening. But what is more important

for him is that at least the country of origin remains faithful to those principles, so that in England the new garden "reigns on its verdant throne, original by its elegant simplicity and proud of no other art than that of softening nature's harshness and copying her graceful touch." The garden must be "a compendium of picturesque nature, improved by the charity of art."[14] A few years before, in 1755, in the periodical *World*, Richard Owen Cambridge argued against "This forced taste, aggravated by some Dutch acquisitions," that "for more than half a century deformed the face of nature in this country," and praised the new taste in gardening: "It is the peculiar happiness of this age to see these just and noble ideas [that is, Temple's ideas] brought into practice, regularity banished, prospects opened, the country called in, nature rescued and improved, *and art decently concealing herself under her own perfections.*"[15]

Even where the formula of *ars est celare artem* is not accompanied by any theoretical investigation, its presence still represents interesting evidence of the opinions on taste. The Duke of Harcourt uses it as an epigraph to his works on landscape,[16] while in M. G. Lewis's famous novel *The Monk*, published in 1796, we can find the following observation of a garden: "In all Madrid there was no spot more beautiful, or better regulated. It was laid out with the most exquisite taste; the choicest flowers adorned it in the height of luxuriance, and, though artfully arranged, seemed only planted by the hand of Nature. Fountains, springing from basins of white marble, cooled the air with perpetual showers; and the walls were entirely covered by jessamine, vines, and honey-suckles."[17]

But the success of *artem celare* in garden literature is not limited to Anglo-Saxon culture. It is also documented in French, Italian, and German works. In France—and the circumstance is not accidental, considering the belief that the new sensibility

for landscapes has an oriental origin—we find it in the description of the Chinese emperor's parks given by the missionary Attiret, who talks, for example, about *rocks so artfully arranged that it seems to be the work of nature*. Another missionary, Father Benoist, is even more explicit: "The Chinese, in the ornamentation of their gardens, employ art to perfect nature so successfully that an artist is deserving of praise only if his art is not apparent and in proportion as he has the better imitated nature."[18] A guidebook to London published in Amsterdam in 1788 describes the "graceful path leading from Windsor to Weybridge," praising, among other things, "the many outlooks arranged *with a fine art that conceals itself*," while in the first canto of Marquis de Saint-Lambert's poem *Les saisons* we read:

O! que j'aime bien mieux ce modeste jardin
Où l'art en se cachant fécondoit le terrain
Où, parmi tous les biens, le luxe et la parure
Sembloient un don de plus, un jeu de la nature.[19]

In De Lille's *Les jardins* we read instead:

mais au fond d'un serrail contemplez la beauté
en vain elle éblouit, vainement elle étale
des atours captifs la pompe orientale
je ne sais quoi de triste, empreint de tous ses traits
décèle la contrainte et flétrit les attraits.[20]

As for German works, we can quote a passage from the entry "Gartenkunst" ("Art of Gardens") in Sulzer's *Allgemeine Theorie der schönen Künste*: "if all the beauty is concentrated [in the garden], the whole should be ordered in such a way that such planned order should not be evident." And we can quote above

all Friedrich Schiller's essay on gardens, written in 1794. In it, the great playwright opposes the architectonic garden, "in which art as such is allowed to show itself," to the English garden, "in which nature should show itself in all its prominence and wilderness, and give the sense of absorbing all art."[21]

Among the Italian works, the epigraph used by Vincenzo Marulli in his essay "L'Arte di ordinare i giardini" (1804) should be noted. In it we find, as in Harcourt's work, the Tassonian line "*l'arte, che tutto fa, nulla si scopre*" ("nowhere appeared the art which all this wrought"), or, better, the complete *ottava* of which that line is a part.[22]

It seems obvious that the naturalness of the English garden is the result of a studied intervention, a product of human craft; in other words, it is something quite artificial: "the genesis of the landscape garden did not entail a mere intrusion of fields and surrounding woodlands onto another terrain. All of newly discovered nature was to be transfigured and transposed into a domain of vision and symbolism. . . . We have shown that Kent's landscapes were in no way intended to evoke some untamed English site."[23] But, one might ask, was this obvious to Kent's contemporaries? The very insistence of many commentators that in the English garden art is actually present though skillfully dissimulated should make us suspect the contrary. Indeed, the principle of *ars est celare artem* is greatly employed by theorists and observers of informal gardening because they want to reject a widespread commonplace associated with the English garden from its birth, or even before. This commonplace, supported by the recurrent opposition between the artificiality of architectonic gardens and the spontaneity of picturesque gardens, presents the English garden in terms of *pure nature*, that is, nature free of displaying itself.

It is not by chance that many English theorists pinpoint the origin of the new taste in the passage of *Paradise Lost* (quoted, as we saw, also by Pindemonte) in which Milton describes the Earthly Paradise before the fall of Adam and Eve, when the beauty of that garden is "not nice Art / In Beds and curious Knots, but Nature boon."[24] Not *nice art*; rather, nature has created not only the primordial garden, *but also* any other landscape garden, this is, the faulty step that many did not hesitate to take, Walpole among them. Walpole, for example, despite his endorsement of the principle of *artem celare*, in drawing the opposition between architectonic gardens, which are "unnatural, enriched by art, possibly with fountains, statues, and balustrades," and picturesque gardens, "verdant and rural," praises, in fact, William Kent for having stressed that "all nature is a garden."[25] The same argument is made by J. M. Morel, author of the coeval *Théorie des jardins*. The idea of gardens that he proposes "is founded on nature itself: nature alone has given precepts, examples, and materials," and the art of gardening "creates, as it were, Nature, because it employs the same materials, arranges them in the same order, and uses the same paths of nature."[26]

Others have tried to minimize the role of art in picturesque gardens in a similar way. For example, W. Mavor describes the Blenheim park designed by "Capability" Brown, the most famous creator of English gardens, as follows: "the river flows with a serpentine sweep through an expanded vale, embellished with scattered groups of flourishing young plantation. . . . At last, the river passing under a low bridge with numerous arches, precipitates itself down a steep cascade. . . . No awkward termination is here to be traced, no disgusting display of art to heighten the scene: taste unfolds the beauties of Nature with a delicate touch, and Art is only the handmaid to her charms."[27] Ercole Silva, the Italian author of an extended essay titled *Dell'arte dei*

giardini inglesi (*Of the Art of English Gardens*, 1801), writes in this respect that "the art of gardening can be praised for its superiority to all other fine arts. It is art, but still it is bound to nature more closely than any other art." Even more directly, he says, "from the comparison between these two arts, it is clear that the art of gardening is as superior to painting as the original surpasses the copy, and indeed no art is more natural than the art of gardens."[28]

A paralogism emerges from these passages that informs the positions voiced, according to which the naturalness of the art of gardens is derived from the naturalness of the *materials* used in gardening. Silva's work relies heavily on Christian Hirschfeld's extended and influential encyclopedia of gardening, titled *Theorie der Gartenkunst*, and on this particular aspect it is clear that he follows him almost literally. Hirschfeld can indeed be considered the most eloquent, if not the deepest, theorist of the garden as *pure nature*. These are the words echoed by Silva: "None of the mimetic arts is more entwined with nature herself, which is to say, more natural, than the art of gardens." The German theorist is committed to the idea that gardens are derived "from nature herself"; he in fact affirms the connection between landscape and gardens, noticing that the objects of gardening are the same of rural nature, and adds: "the art of gardening is so precisely connected to nature that it seems to be nothing other than nature herself in a somewhat altered form." Of course, Hirschfeld is well aware of the obvious absurdity of denying human intervention in the creation of gardens and thus the presence of artifice in it. In some passages he even seems to endorse the principle of *ars est celare artem*. But his reluctance to use the term *art* in reference to gardens is quite symptomatic. The expression *art of gardens*, he writes, may be misleading, because it "should not be understood as an attempt to improve without

regard for nature's guidance, to subject her to artificial forms and layouts, to demand effects that are unfamiliar to her. . . . Here *art* means uniting those things that are agreeable and interesting in nature in exactly the same way and by exactly the same means as she herself does, and knowing how to collect in a single place the beauties that she scatters throughout her landscapes." The work of the gardener is based on the observation and the selection of nature, and once the work is done "a new nature is revealed to the eye." On this point, the idea of landscape gardens as a purely natural entity relies on the famous theory of ideal beauty, according to which beauty indeed lies in nature, and the artist does nothing but "abstract from" and "arrange" it: she isolates and combines it. The theoretical prerequisite of the English garden is still completely mimetic, and this allows us to dispel the notion of the English garden as a Romantic kind of garden: it is rather a classicist garden, and indeed Romantic authors, or at least a good portion of them, did not hesitate to criticize such shared belief.[29]

Against all these simplifications, and above all against the denial of the very artistic character of the landscape garden, it is better to trust the *lectio difficilior* attached to the idea of art concealment—the idea that even in the most informal garden there is a great deal of art, although it strives to remain concealed. Luigi Mabil writes that an English garden is good in the measure in which it leaves us in a perennial state of pleasant wavering, preventing us from deciding whether what we are seeing is spontaneity or artifice, nature or imitation. This is why it is not enough to copy natural sites, but rather always necessary to try to capture "the right disposition, physiognomy, and attitude a garden must possess if it is to produce a pleasant misunderstanding: the delightful doubt of whether the scene, with its unexpected particulars and frames, has been arranged by nature or art."[30]

In his poem, de Lille defines the landscape garden as "an obser-
vant lover of nature," which "*l'orne sans la farder, traite avec
indulgence / ses caprices charmants, sa noble négligence / sa marche
irrégulière, et fait naître avec art / les beautés du désordre et même du
hasard.*"[31] The natural garden is indeed a fiction, though it con-
sists of a fictional naturalness: "the attempt to reproduce an ef-
fect of naturalness in the delimited space of a garden is . . . an
additional fiction. Whether ancient or modern, English or Chi-
nese, what we look for in a garden is actually not nature, but
rather shelter and protection. And art and human interven-
tion, always holding the stage, are as much effective as they are
concealed."[32]

If something akin to this kind of awareness is implicit in the
thinking of those who drew upon the principle of *ars est celare
artem* in gardening (and, as we saw, there were many indeed),
nonetheless there were only a few authors for whom the aware-
ness of the indispensability of art in landscape arrangement
(and thus of the necessary presence of illusion in all "natural"
gardens) was acute and became particularly manifest. One of
them is William Chambers, who not only contributed more
than anybody else to substantiate the thesis of an oriental origin
of the modern garden, but also criticized all the naïve remarks
about naturalness and spontaneity that seemed to be common
ground for many admirers of the new garden. Far from pure
nature and free-growing flora, "in the absence of art, nature is
rarely tolerable." If we give heed to these simplifications, we run
the risk of not being able to distinguish between a garden and a
wild moor anymore: "In England, where this ancient style is
held in detestation, and where, in opposition to the rest of
Europe, a new manner is universally adopted, in which no ap-
pearance of art is tolerated, our gardens differ very little from
common fields, so closely is common nature copied in most of

them." Chambers is not nostalgic for the regular garden, the French variety, but neither is he fond of "Capability" Brown's informal garden, and of all the gardeners ready to substitute art for nature: "Art must therefore supply the scantiness of nature; and not only be employed to produce variety, but also novelty and effect: for the simple arrangements of nature are met with in every common field, to a certain degree of perfection; and are therefore too familiar to excite any strong sensations in the mind of the beholder, or to produce any uncommon degree of pleasure." In this case, Chinese gardens are the exemplification of a third way between abstract regularity and the refusal of artificial intervention: "Though the Chinese artists have nature for their general model, yet they are not so attached to her as to exclude all appearance of art; on the contrary, they think it, on many occasions, necessary to make an ostentatious show of their labour."[33]

Once again, the principle of *ars est celare artem* proves itself to be characterized by internal tensions, making it essentially unstable: *born as a praise of spontaneity, it can end up being a praise of the highest degree of artificiality, and vice versa.* In fact, in the cases just mentioned, we witness a shift in the usual meaning of *artem celare*, which amounted almost to the restoration of its opposite, that is, ostentation. In this direction, a similar conclusion is drawn by the painter Joshua Reynolds, who in his *Discourses on Art* writes: "So far is art from being derived from, or having any immediate intercourse with, particular nature as its model, that there are many arts that set out with a professed deviation from it. . . . So, also, gardening—as far as gardening is an art, or is entitled to the appellation—is a deviation from nature; for if the true taste consists, as many hold, in banishing every appearance of art, or any traces of the footsteps of man, it would then be no longer a garden."[34]

But there is at least one thinker who managed to preserve all the paradoxical and illusive aspects of the idea of a spontaneous garden without giving up the principle of *ars est celare artem*. This thinker is no less than Jean-Jacques Rousseau, who, in the fourth part of *Julie ou la nouvelle Héloïse*, introduces a long description of the garden created by Julie for Clarens—a description inspired by marquess de Girardin's garden of Ermenonville, which has been very influential in the shaping of European taste for landscapes and gardens.[35] When Saint-Preux enters Clarens's Élysée, his first impression is that of an absolutely natural site: "I thought I was looking at the wildest, most solitary place in nature, and it seemed to me I was the first mortal who ever had set foot in this wilderness." Soon after, Julie tries to disillusion him, using a word that evokes the highest degree of artificiality, that is, "charm": "Many people find them here as you do, but twenty paces more bring them quickly back to Clarens: let us see whether the charm lasts longer with you." But Saint-Preux insists: "This place is enchanting, it is true, but rustic and wild; I see no human labor here. You closed the gate; water came along I know not how; nature alone did the rest and you yourself could never have managed to do as well." On the contrary, that was the result of Julie's art. She overlooked the growth of trees and arranged the bushes that adorn the ground to "make it appear wild." The branches of the most flexible trees have been bent back to the ground, so that they themselves could take roots, "with an art similar to what mangroves of America do naturally." But Saint-Preux is not yet persuaded: "there is something here I cannot understand. It is that a place so different from what it was could have become what it is only through cultivation and upkeep; yet nowhere do I see the slightest trace of cultivation. Everything is verdant, fresh, vigorous, and the

gardener's hand is not to be seen: nothing belies the idea of a desert island which came to my mind as I entered, and I see no human footprints." Finally the secret is unveiled by Wolmar, Julie's husband, who, again, appeals to *ars est celare artem*:

> That is because we have taken great care to erase them. I have often been witness, sometimes accomplice to the trickery. We have hay sown on all the spots that have been plowed, and the grass soon hides the traces of labor; in the winter we have the thin and arid places covered with several beds of manure, the manure eats up the moss, revives the grass and plants; the trees themselves are no worse off for it, and by summer none of this is visible.

Saint-Preux cannot help but recall the Chinese gardens, as usual: "Moreover, in China I saw gardens such as you are calling for, and done with such art that the art was invisible, but in so expensive a manner and maintained at such great cost that this thought took away all the pleasure I could have derived from beholding them." Wolmar, on the other hand, explicitly theorizes our principle: "The mistake of so-called people of taste is to want art everywhere, and never to be satisfied unless art is apparent; whereas true taste consists in hiding art; especially where the works of nature are concerned."

And it would be a mistake as well to ask whether it is odd to strive for concealing the efforts made, since, as Julie patiently explains:

> Nature seems to want to veil from men's eyes her true attractions, to which they are too insensible, and which they disfigure when they can get their hands on them: she flees much frequented places; it is on the tops of mountains, deep in the forests,

on desert islands that she deploys her most stirring charms. Those who love her and cannot go so far to find her are reduced to doing her violence, forcing her in a way to come and live with them, and all this cannot be done without a modicum of illusion.[36]

As we saw already, in section 45 of the *Critique of the Power of Judgment*, Kant seems to report almost literally Longinus's principle, according to which nature is beautiful when it has the appearance of art, while art is beautiful when it resembles nature. In order to make this possible, it is necessary that the artist is able to conceal all efforts and simulate easiness. "A product of art appears as nature, however, if we find it to agree punctiliously but not painstakingly with rules in accordance with which alone the product can become what it ought to be, that is, without the academic form showing through, i.e., without showing any sign that the rule has hovered before the eyes of the artist and fettered his mental powers." In section 42, however, talking about the moral value of loving natural beauty, Kant writes that "this interest, which we here take in beauty, absolutely requires that it be the beauty of nature; and it disappears entirely as soon as one notices that one has been deceived and that it is only art, so much so that even taste can no longer find anything beautiful in it or sight anything charming."[37]

Neither passage contains any particular reference to the art of gardening. Moreover, since they answer two different questions, it is sound to argue that the two arguments are not necessarily contradictory. But if we read the Kantian passages in the light of the art of gardening, they seem to be singling out two quite different positions. On the one hand, we could say that if we consider the landscape garden as *art*, then its illusive and simulative character—its pretension to naturalness—becomes

not only acceptable, but actually praiseworthy (it consists in great art precisely because it makes us forget its being art); on the other hand, if we consider the garden as *nature*, it becomes possible to criticize it for its artificiality, in a way that reminds us of the Kantian example about the singing bird: once we become aware of the fact that such captivating singing is actually a human imitation, we lose any interest in it. The English garden strives to be spontaneous. But how is it possible to achieve spontaneity through *effort*, that is, a studied spontaneity?

This is a recurring difficulty (and one that is hardly answerable) for those who reflect on the peculiar status of gardening as one of the arts and its paradoxical condition in relation to the *mimetic* character of the arts. An Italian scholar, F. Testa, notes that "The informal garden, the result of a classical aesthetical theory that uses the *mimesis* as an instrument of ontological foundation of artistic representation, eventually shows the very limits of the classical mimic system, denouncing its paradoxes."[38] This is clearly exemplified by Pindemonte's text quoted at the beginning of this chapter. In its central section we find a critique of the English garden (which functions to rehabilitate of the regular garden) based on its ambiguous positioning among other arts. The art of the English garden, as Pindemonte observes, undertakes the imitation of nature through its embellishment. As he states, "Let's check whether it deserves such a high praise." To imitate nature means to have access to the material necessary for the imitation, just like stone for sculptors; but this material seems not to be available in gardening, because in it the *medium* and the *object* of imitation coincide, being nature itself in both cases: "there is no true imitation, where the same material employed by nature is used."[39] This means that gardening cannot be an imitative art, since it is not clear "how one can imitate nature by means of nature."

However, one might still think that gardening is an art, because what really matters is the pleasure it brings. But in the comparison between "nature arranged by men," as in a landscape garden, and a "beautiful natural scene," our pleasure would be infinitely increased by the consideration that "beauty is the off-spring of chance," whereas in the presence of a "beautiful artificial scene," even if our first impression might be delightful, it would soon be diminished because "knowing that such muddle is the result of a study would make it very hard to enjoy." We are amazed by the result of natural spontaneity, which works without any premeditated design, and we are suspicious when the skills required by art are displayed: "having the works of art in great esteem, in comparison to which chance seems to have no place, it is clear that the products of the former, rather than the efforts of the latter, shall astonish and delight us."[40]

Similar thoughts are expressed in Schiller's aforementioned essay on gardens, which is aimed at finding a *third way* between the abstract regularity of the French garden and the excessive freedom of the English garden. For Schiller, the placement of gardening among other arts is problematic too. Yet he believes that it would be a mistake to deny any artistic character to gardening. Gardening has something in common with architecture, of course, but this depends not as much on its utilitarian character as on the fact that both architecture and gardening "imitate nature by means of nature, rather than by means of some artificial means, or rather by not imitating it at all and producing instead its own objects." This makes understandable how the assimilation of gardening into architecture could have been overstated, producing the excess of the geometrical garden. On the other hand, its affinity with painting (an affinity much appreciated by the theorists of informal gardening) cannot be

denied, and yet the observer should not forget that "the plea-sure provoked by the sight of a landscape goes together with the recognition that that is a free work of nature, and not of art." Hence, if one aims to provoke this kind of pleasure, one should try to eliminate from all creations "any trace of artistry." Free-dom becomes the supreme law, and nature must prevail. This can happen in landscape painting, but not always in gardening. Creators of English gardens forgot that the unit of measure that can be adopted in painting "cannot be applied to an art repre-senting nature through itself, and which is able to touch us only if mistaken for nature." Taken literally, the illusion created by English gardens is not distinguishable from phenomenal reality.[41]

Similar arguments were employed by the opponents of the English garden for quite some time. For example, A. W. Schle-gel, one of the champions of German Romanticism, denies that gardening can be considered an autonomous art, and, in the comparison between architectonic and picturesque gardens, he carefully avoids defending the latter (confirming in this way how misleading it is to equate the English garden with the Romantic one). "The English garden consists of a painted landscape with real objects, able to provoke agreeable dispositions, but which because of this can never be fully separated from nature, so to be completed in itself as a pure work of art." In *The World as Will and Representation*, Schopenhauer expressed similar sentiments.[42] But the thinker who expressed the most incisive discomfort with what he called *the affectation of spontaneity* of the English garden is perhaps Hegel, who in his *Aesthetics* writes:

> In a park like this, especially in modern times, everything should preserve the freedom of nature itself and yet at the same time

be transformed and fashioned artistically; it is also conditioned by the existing terrain. The result is a discord which cannot be completely resolved. In this matter, nothing is in the main more tasteless than to make visible everywhere *an intention in what has none or such a constraint on what is in itself free from constraint.*[43]

6

IKI

I t is plausible that Western philosophers first heard about the word *iki* on the occasion of the publication of Martin Heidegger's *On the Way to Language*. In one of the essays in that anthology, "A Dialogue on Language," Heidegger portrays a Japanese person and an inquirer (which is Heidegger himself) discussing *iki*. The conversation revolves around the very impossibility, rather than the difficulty, of understanding its meaning: "But we were discussing *Iki*; and here it was I [the inquirer is talking] to whom the spirit of the Japanese language remained closed—as it is to this day." Indeed, the word *iki* is used to express a crucial concept for "*East Asian* art and poetry," and trying to translate it into *Western* aesthetics terms means for Heidegger considering it within the categories of *metaphysics* (aesthetics, in his opinion, is a late outcome of metaphysical thought), something absolutely distant from the Eastern way of thinking.[1]

Heidegger wrote the dialogue in 1953–54 (the anthology wasn't published until 1959), and he was likely inspired by the visit of Prof. Tezuka from the University of Tokyo to Germany. But in the dialogue there are many references to another Japanese scholar whom Heidegger met many years before, Kuki Shuzo. A descendant of an old and important Nipponese family

(his father held a governmental position), Kuki (1888–1941) studied philosophy in Japan and in the early 1920s moved to Europe to deepen his knowledge of contemporary Western thought. He studied under Heinrich Rickert at the University of Heidelberg, and then moved to Paris, where he met Henri Bergson and Paul Valéry at the Sorbonne in the years between 1925 and 1927. He later returned to Germany, this time Marburg, where he attended Heidegger's courses and became his friend. Back in Japan in 1929, he took a teaching position and then, in 1935, became professor of Western philosophy at the University of Kyoto. There, his first important work was an essay on *iki* titled "The Structure of Iki." It was published as a book at the end of 1930. Heidegger might have found in this essay not only a confirmation of his own theory about the impossibility of understanding *iki* by employing the categories of Western thought—Kuki repeatedly remarks that the word *iki* manifests "specific colorings of the experience of that ethnic group, as the expression of the being of that group"[2]—but also the most careful attempt to explain its meaning and investigate its nature. At the time Heidegger was writing his "Dialogue on Language," Kuki's book had not been translated into any Western language, and, despite the fact that Heidegger was likely aware of its several Japanese editions, the work still remained beyond his reach.

In contrast, we now have, among others, the English translation by Hiroshi Nara published in 2004, which is a good starting point for grasping at least some of the features of *iki*. But first we have to say something about the word itself. *Iki* is a substantive (the adjectival form is *iki-na*, but here we will be using *iki* both as a noun and as an adjective), probably derived from classical Chinese. In Japan, since the twelfth century, it has carried the meanings "disposition of the soul," "sentiment,"

and "courage," and until the eighteenth century it meant "mastery," "energy." One century later, it gained a different, though connected, meaning, that is, "subtly elegant, refined with no ostentation," and it is used especially in reference to the paramours of the pleasure quarters of Edo, the future Tokyo. This is the "fluctuating world" immortalized in Utamaro's prints and mythologized by Western people after Goncourt's works. This refined and seducing world, provided it existed in the way we imagine it, disappeared with the reforms of the late eighteenth century, but the term *iki* continued to be used. "In modern language the term *iki* has been employed with reference to different aspects of the human life: it can be said that a certain character is *iki* if endowed with a nonchalant mind and attitude, a person who only needs a few words to get hold of the situation, and who dresses smartly yet without affectation."[3]

Kuki's book cuts off almost any connection between the Fluctuating World and *iki*.[4] He is in fact not interested in the local context and ethnic coloring; rather, he aims for a theoretical clarification of the term, adopting the Heideggerian method of the hermeneutics of existence. The readers of Kuki's book thus have the impression, at the same time disorienting and familiar, of reading a version of *Being and Time*, whose object is, however, not the sense of being but the meaning of *iki*.[5] Kuki begins by asking whether there are possible equivalents of the term *iki* in Western languages, and we immediately sense, on the basis of what he has just said about the "specific ethnicity" of the word, that the answer will be negative. Kuki knows, as we also know, that universal words simply do not exist, that there are no perfectly equivalent meanings across languages; but it is also clear that he wants to claim something more, that is, that *iki*, being essentially part of Nipponese culture, is an absolutely untranslatable term. But, in so doing, perhaps he goes too far, as

the reformulations proposed in his book are, if not synonyms (which, in absolute terms, do not exist even within the same language), at least indicative, albeit incomplete, approximations.

The first candidate discussed by Kuki, the French *chic*, has something in common with *iki*, especially because of its derivation from the German *geschickt* (skillful, dexterous, handy), and yet it expresses aspects that do not pertain to *iki* or are even opposed to it, such as the pursuit of distinction and the ostentation of taste. A second candidate, namely, *coquet* (coquettish, nice, tidy), is indeed very promising, since it originally refers to the sphere of gallantry and seduction, and *coquetterie* "does indeed symbolize one of the many facets of *iki*."[6] But, taken alone, *coquet* is unable to encompass the entire range of meanings of *iki*, also because, if overplayed, it becomes affectation or even vulgarity, which are the very opposite of *iki*. Kuki, who limits the search to French and German equivalents, does not take into consideration that one possible meaning of *coquetterie* is indeed *grace*. However, the Japanese interlocutor in Heidegger's dialogue uses precisely this term, claiming that "*iki* is the grace." Obviously, this statement is part of Heidegger's replies that the concept of grace is associated with Kant via Schiller's *Ueber Anmut und Würde* (*On Grace and Dignity*), hence running the risk of falling back into a metaphysical definition. Finally, Kuki takes into account the word *raffiné* (refined), and says that it "also expresses one of the many facets of *iki*. But, again, it still lacks something very important to encompass the entire meaning of *iki*."[7]

Kuki's next step is an attempt to clarify the "intensional structure of *iki*" through the definition of some of its essential components. *Coquetry* represents the first component. The erotic is an essential part of *iki* (*ikigoto*, an *iki* affair, is synonymous of *irogoto*, a romantic affair), provided that the focus is on

the seductive *process* and not on its conclusion: by putting an end to seduction, the conquest is not equivalent to *iki*. The second component consists of a series of attributes that pertain to behavior, bringing us back to the original meaning of *iki*. *Iki* is a kind of self-confidence, a boldness without bravado or arrogance, rather a sort of heedlessness and detached gentility shown, for example, in the managing of money. In this sense, *iki* is a form of "vital energy." However, its ultimate defining trait is perhaps the third and last, which Kuki (or, better, his translator) expresses through the words *resignation, acceptance,* meaning "a disinterest which, based on the knowledge of fate, permits us to detach ourselves from worldly concerns."[8] One is not born *iki*; rather, one becomes *iki* by acquiring over time the capacity to accept sadness and disillusion in life. There is a story, a method, behind what Kuki interestingly describes as "a frame of mind that is light, fresh, and stylish." The *resignation* and *carelessness* of *iki* represent the perfect superiority of a soul that "has suffered through hard *ukiyo*'s tough and merciless tribulations and shed worldly concerns; in other words, the state of mind that is free of grime, unclinging, disinterested, and free from obstacles, and that has removed itself from any egotistical attachment to reality."

In the chapter titled "The Extensive Structure of *Iki*," Kuki tries to clarify the meaning of *iki* by comparing it to a series of connected terms, more precisely to a series of antonyms: elegant, high class/crude, unsophisticated; flashy/quiet; understated, astringent/sweet. Contrary to what one might believe, *iki* is opposed not only to the second terms in this series, but also and necessarily to the first ones, without it being a middle term between the two. For example, while it is true that *iki* is antithetic to unsophistication, in a sense it is antithetic to elegance as well. Indeed, if we add something to elegance, that will turn into *iki*,

but we should be extremely careful not to exceed, because an *excessive* elegance is anything but *iki*. Something very similar happens with the pair flashy/quiet. *Iki* is never flashy; it is rather a form of elegant discretion: the kimono of a woman with *iki* "does not show much of the pale violet lining on the collar and sleeves, who is clad in a lusterless Yūki kimono, with a stripe design in which a red thread has been woven in." On the other hand an excessive sweetness is flawed as well, as it turns into mawkishness. And the *grand seigneur* attitude is a form of not inurbane harshness of manners, a kind of austerity often perceived as sourness.

From our perspective, it is also interesting to examine the terms diametrically opposed to *iki*, as that will lead us to familiar places. Now, we might ask, what is *iki not*? First, it is not *clumsiness*. What is in fact most distant from the qualities of *iki* is coarseness, uncouthness, villainy, boorishness, and provincialism. Even in the merely physical sense, those who are clumsy are not *iki*, and one can only be *iki* if slim, willowy, and slender, like the geishas of Utamaro's lithographs. Moreover, *iki* is not affectation, nor it is *snobbery*. A snobby person is not *iki* because she wants to parade elegance as a status symbol, whereas *iki* elegance is always unconcerned about status. Above all, *iki* is a sort of neglected and most importantly signed-by-time elegance, for which the Japanese language has a word, *sabi*, that is, elegant simplicity. *Iki* or *sabi* as the shabby chic.

In the light of what has been said so far, the title of the third chapter of Kuki's book, "The Natural Manifestation of *Iki*," may appear odd: it seems in fact difficult to imagine how nature can be *iki*, or how one can be natural and *iki* at the same time. And in fact Kuki is talking not about nature, but about human behavior. The human voice is *iki* if it is sensual without becoming mawkish (in the case of women) or gross (in the case of

men). One's posture will be *iki* if it avoids ostentation, remaining at the same time elegant. Woe to coarse manners and alluring poses, woe to exaggerated sensuality! Boldness is the enemy of *iki*, allusiveness its deepest secret. And as clumsiness cannot be *iki*, a slim and slender body can be *iki*, which is the only capable way of expressing the weakness of the flesh and the strength of the spirit, in accordance with the first definition of *iki* as "spiritualized coquetry." *Iki* beauty is not radiant, sunny, or triumphant, but rather melancholic, autumnal, like late summer (the Germans speak of a *Nachsommer* beauty). And bodily ornaments must meet these ideals. Heavy, thick makeup is not *iki* because only light and almost invisible makeup could be *iki*: "We can see the material and formal causes of *iki* both in this expression of *bitai* in applying makeup and in positing idealism that confines it to a mere suggestion."[9] As for hair, it should not betray any care, and even better if it appears hastily arranged, as in "the straggling hair from the night before on a woman's face," "artfully neglected," as in Petrarch or Tasso.

In closing, Kuki addresses the question of what *iki* is in art. He immediately excludes the mimetic arts, which he calls "objective arts," such as painting, sculpture, and poetry, because, qua representative arts, one can never understand whether *iki* is the mode of representation or what is represented. So he focuses on nonrepresentative arts, like architecture, music, and the decorative arts. As with architecture and music, his observations are highly technical and scarcely understandable by those unfamiliar with Nipponese art—though it is meaningful that architecture is *iki* when able to avoid gaudiness and vulgarity. The observations become accessible when at issue are abstract motifs and the colors of decorations. Once again, according to Kuki, *iki* manifests itself as vital energy that, however, shows resignation. This means, for example, that "fabrics having myriad of

colors cannot express *iki*. In particular, as *colors* are concerned, bright and vivid tones should be avoided. Flashy colors are never *iki*, as it is not the combination of many different colors. Truly *iki* are those colors that we might characterize as lifeless, as the shades of grey, brown and blue." In fact, "if we were to express the *akirame* 'resignation,' a component of *iki*, in color, nothing would be more appropriate than gray," while browns "embody *iki* because the opulent characteristic of a color and the loss of saturation express a sophisticated sensuality and a coquetry that knows resignation," a sensuality capable of restraining itself.

Kuki's last passage consists of a reformulation of *iki* in terms of *taste*, or, better, an ethnically determined taste. *Taste* is a word that surely does not sound neutral to our ears, for it is saturated with a long tradition of aesthetic reflection. But Kuki seems interested above all in stressing both the aesthetic and the ethical reach of *iki*: "when we talk about a person's, or an ethnic group's taste, we are speaking about ethical and aesthetical judgments we see them making.[10] In this it reminds us of a term that should now be familiar, which on several occasions has seemed to be tacitly at play in the reformulations of *iki* proposed in Kuki's book. Every time we read that *iki* distances itself from affectation, ostentation, vulgarity, clumsiness, and every time Kuki points out that it is a superior form of carelessness, we have glimpsed for an instant the typical traits of *sprezzatura*. And it is not by chance, even if we may lack the linguistic competence to verify the pertinence of this choice, that the Italian translator of Kuki, in her attempt to find what the author has declared in principle impossible to have, uses on many occasions the old word of the *Courtier*. So *Iki* is defined as the "perfect *sprezzatura* of the soul," "an erotic attraction endowed with *sprezzatura* [resignation] and *hari* [spiritual tension]"; its opposite,

coarse vulgarity, is rendered as "without *sprezzatura*," while an *iki* hairstyle is that which, in being free from affectation, betrays *sprezzatura*.[11] In the terminological glossary at the end of the Italian edition of *The Structure of Iki*, we read the following definition: "*Iki* would thus amount to the capacity to manage situations of emotive distress, or to combine spontaneity and artifice so to reach a superior degree of refinement both on the aesthetic and on the ethical level." Perhaps it would be inaccurate to say that *iki* perfectly corresponds to *sprezzatura*, and that it consists merely in the concealment of art, skills, and elegance; yet it wouldn't be too far from the truth to say that the Japanese would consider *sprezzatura* very *iki*.

Moreover, the dissimulation of skills, the necessity to conceal art, and the ease and apparent simplicity as necessary requirements of conduct and artistic practice are anything but alien to Eastern cultures.[12] Consider, for example, this Taoist writing, an interesting *Zhuang-zi* apologue that has been opportunely compared to Castiglione's writings about *sprezzatura*:

> Cook Ting was cutting up an ox for Lord Wen-hui. At every touch of his hand, every heave of his shoulder, every move of his feet, every thrust of his knee—zip! zoop! He slithered the knife along with a zing, and all was in perfect rhythm, as though he were performing the dance of the Mulberry Grove or keeping time to the Ching-shou music.
>
> "Ah, this is marvelous!" said Lord Wen-hui. "Imagine skill reaching such heights!"
>
> Cook Ting laid down his knife and replied, "What I care about is the Way, which goes beyond skill. When I first began cutting up oxen, all I could see was the ox itself. After three years I no longer saw the whole ox. And now—now I go at it by spirit and don't look with my eyes. Perception and understanding have

come to a stop and spirit moves where it wants. I go along with the natural makeup, strike in the big hollows, guide the knife through the big openings, and follow things as they are. So I never touch the smallest ligament or tendon, much less a main joint.

A good cook changes his knife once a year—because he cuts. A mediocre cook changes his knife once a month—because he hacks. I've had this knife of mine for nineteen years and I've cut up thousands of oxen with it, and yet the blade is as good as though it had just come from the grindstone.

There are spaces between the joints, and the blade of the knife has really no thickness. If you insert what has no thickness into such spaces, then there's plenty of room—more than enough for the blade to play about it. That's why after nineteen years the blade of my knife is still as good as when it first came from the grindstone.

However, whenever I come to a complicated place, I size up the difficulties, tell myself to watch out and be careful, keep my eyes on what I'm doing, work very slowly, and move the knife with the greatest subtlety, until—flop! the whole thing comes apart like a clod of earth crumbling to the ground. I stand there holding the knife and look all around me, completely satisfied and reluctant to move on, and then I wipe off the knife and put it away.[13]

It is not by chance, then, that Taoism has been described as an *aesthetic of the empty space*. Giangiorgio Pasqualotto, in his remarks about the passage just quoted, observes that this "art" or "technique" of mastering voids "is not limited to the case of butchering," and indeed in Taoist writings is invoked in many other activities, such as "playing music, carving, swimming, fencing, etc." He adds:

One gives proof of "the great skill that seems to be the absence of skill" only when the mastering of the void is at play. This "great skill" is characterized by the absence of intentionality and, therefore, of effort; thus a work is completed when the ego is put aside and the efforts disappear; executions reach perfection when the hard exercise on the empty spaces conceals the will and the tension of training. In brief: the "great ability" comes into view when the "small ability" disappears.[14]

In the modern arts of acting and painting maximum efficacy and perfection are reached when the artist forgets her technique, or better when she has mastered it to such an extent that she can conceal all traces of intentionality and will.

Perhaps the best example of this is offered by a Zen Buddhist text that circulated in Western countries. It is a short book written by a German philosophy professor, Eugen Herrigel, who was appointed to teach at the Imperial University of Sendai in 1924, and who spent more than five years in Japan. The book is titled *Zen in der Kunst des Bogenschiessens* (*Zen in the Art of Archery*) and it was published in more than thirty editions.[15] Herrigel describes how he wanted to approach Zen through one of the arts, namely, archery, permeated by the spirit of this doctrine that was so distant from European thought. With the help of a university colleague he was accepted as a disciple of one of the most famous masters of archery and, after assuaging the master's initial suspicions, he began training that lasted until he left the Land of the Rising Sun. Learning archery proved to be very difficult for him. Herrigel was most struck by the master's insistence that the physical exercise and the concentration of energy required to draw the bow must originate from an absolute ease of movement and be executed without any muscular waste. "When drawing the string you should not exert the

full strength of your body," explains the master, "but must learn to let only your two hands do the work, while your arm and shoulder muscles remain relaxed, as though they looked on impassively." Even at the point of highest tension, the master's muscles "were quite relaxed, as though they were doing no work at all," while the disciple was always too tense and strained. "Relax! Relax!" the master often repeated, just like Chopin reproached "*facilement, facilement*" when teaching his pupils.[16]

But for Herrigel this ease of movement and facility were the most difficult thing. "Whenever I tried to keep my arm and shoulder muscles relaxed while drawing the bow, the muscles of my legs stiffened all the more violently, as though my life depended on a firm foothold and secure stance, and as though, like Antaeus, I had to draw strength from the ground." The bow must be drawn gently and elastically, "with strength and yet without effort." "The effortlessness of a performance for which great strength is needed is a spectacle of whose aesthetic beauty the East has an exceedingly sensitive and grateful appreciation," while the West finds it impossible to understand how such an outcome might be reached. Herrigel *thinks* about the goal, and this works against relaxation and forces muscles to contract. "Don't think of what you have to do, don't consider how to carry it out!" exhorts the master, while the pupil "seems like the centipede which was unable to stir from the spot after trying to puzzle out in what order its feet ought to go." It seems impossible for the Western logical spirit to escape from this double bind, the contradiction in which it finds itself: "So I must become purposeless—on purpose?" says Herrigel. He must appear to be natural, but put effort into being relaxed. "When, to excuse myself, I once remarked that I was conscientiously making an effort to keep relaxed, he replied: 'That's just the trouble, you

make an effort to think about it. Concentrate entirely on your breathing, as if you had nothing else to do!'"[17]

Another complex concept for those of us in the West is the *purposeless* character of this art. To hit the target is not important. "The right art is purposeless, aimless! The more obstinately you try to learn how to shoot the arrow for the sake of hitting the goal, the less you will succeed in the one and the further the other will recede." *To obtain is to obtain not*, says the wise man. Things must appear as though they were done by themselves. "All right doing is accomplished only in a state of true self-lessness, in which the doer cannot be present any longer as 'himself.'"[18]

In order to give expression to this particular state and clarify the pitch of perfection that has to be reached by the archer, Herrigel uses the locution *artless art*. Movements must be performed *as if* they were not learned: "instead of reeling off the ceremony like something learned by heart, it will then be as if you were creating it under the inspiration of the moment, so that dance and dancer are one and the same." In every art permeated by the Zen spirit (be it dramatic art, a tea ceremony, the art of arranging flowers or that of swordsmanship) the supreme art is the art that does not appear to be art anymore. Thus, in the art of ink painting "the instructions might be: spend ten years observing bamboos, become a bamboo yourself, then forget everything—and paint";[19] or, in the *zuihitsu* literary style, "the brush finding its own way on the page, creating in elegant handwriting scattered thoughts as if they came effortlessly, without any apparent work, in order to perceive, elaborate, and express them," in which, however, "the spontaneity of the phrase, and behind it of the concept or sentiment, is at once the outcome of a patient work of refinement and polishing of the expressive

mean and of one's own personality."[20] The Tao says: "Great perfection seems flawed / Its function is without failure / Great fullness seems empty / Its function is without exhaustion."

The deepest nature of *artless art* is clarified by the master when he says:

> He who can shoot with the horn of the hare and the hair of the tortoise, and can hit the centre without bow (horn) and arrow (hair), he alone is Master in the highest sense of the word 'Master of the artless art. Indeed, he is the artless art itself and thus Master and Not-Master in one. At this point archery, considered as the unmoved movement, the undanced dance, passes over into Zen.[21]

We now understand that the aim of this aimless art is the radical transformation of the archer's personality, and that this transformation is the answer given by the Zen to the apparently inextricable dilemma of becoming purposeless on purpose. If being relaxed, being spontaneous, and being natural are *states that are essentially by-products*—that is, states that can be reached only, if not directly pursued, in themselves—then the only possibility of reaching them is behaving like the shot of the perfect archer. Grace, *sprezzatura*, *artem celare* cannot be achieved through a deliberate effort, but this does not mean that they are immediate gifts, or that they do not require any study. In fact, it took Professor Herrigel five years to realize that there is a third way to reach them.

7

THOSE WHO CANNOT DISSIMULATE CANNOT RULE EITHER

The art of archery and the art of swordsmanship, the art of serving tea and the art of arranging flowers, and then, beyond the East, rhetoric and makeup artistry, sculpture and painting: it seems that there is virtually no limit to the range of arts to which our precept applies. Both the *fine arts*, that is, art in the modern aesthetic sense, and ancient *artes*, that is, techniques, or skills, acquired by expertise, are equally featured in its discussion. The principle of *artem celare* has also been applied to unexpected fields already in the classic epoch. While it is not surprising to see it applied to dancing, as in Lucian's *De saltatione* ("As in literature, so too in dancing what is generally called 'bad taste' comes in when they exceed the due limit of mimicry and put forth greater effort than they should"),[1] it is indeed quite curious to see it associated with horsemanship, as in Xenophon's treatise *On the Art of Horsemanship* ("For what a horse does under constraint, . . . he does without understanding, and with no more grace than a dancer would show if he was whipped and goaded").[2] Although in the latter case the principle is, perhaps, only hinted at rather than explicitly theorized, it is intentionally applied by Ovid in his *Ars amatoria*, the art of loving. The Latin poet, who has already been quoted with regard

to the concealed art in Pygmalion's sculptures and in his mastery of cosmetics, points out, in his vade mecum on erotic strategies, the necessity of capturing the object of desire by abounding in praises. Adulation never comes amiss, and one must always be ready to pretend to be enraptured and astonished by the beauty of one's object of desire. About any dress it must be said that it perfectly suits, about any hairstyle that it is perfect. If one wants to win over a woman who is a dancer, her movements must be admired; if she sings, her voice must be praised. And once the show is over, one must complain for its too-short duration. But one must be extremely careful that this strategy is not revealed:

> Tantum, ne pateas verbis simulator in illis.
> Effice nec vultu destrue dicta tuo.
> Si latet ars, prodest; adfert deprensa pudorem
> Atque adimit merito tempus in omne fidem

> Be cautious lest you overact your part,
> And temper your hypocrisy with art;
> Let no false action give your words the lie,
> For once deceiv'd, she's ever after shy.[3]

It is clear that in Ovid's verses the principle of *artem celare* is drawn from rhetoric, and this derivation is even clearer in book I of *Ars amatoria*, where forensic rhetoric and erotic rhetoric are directly compared:

> Disce bonas artes, moneo, Romana iuventus,
> Non tantum trepidos ut tueare reos;
> Quam populus iudexque gravis lectusque senatus,
> Tam dabit eloquio victa puella manus.
> Sed lateant vires, nec sis in fronte disertus.

Learn eloquence, ye noble youth of Rome,—
It will not only at the bar o'ercome:
Sweet words the people and the senate move;
But the chief end of eloquence is love.
But in thy letter hide thy moving arts,
Affect not to be thought a man of parts.[4]

Mario Equicola, a contemporary of Castiglione, recalls this Ovidian advice in his *Libro de natura de amore* (*Book on the Nature of Love*): "when she sings or dances, be astonished, and when she stops, complain for having been deprived of such a pleasure. But be cautious lest you do not appear false, 'cause once your art is manifest, your words will be no more trusted for the rest of your time"; and, speaking in particular about the lover's manners and gestures, he insists on the "beautiful eloquence," exhorting the lover not to be "crude in his art, because the true art is the art that remains invisible."[5]

Those acquainted with the *Courtier* may be prepared for these variations of the principle of *ars est celare artem*. Indeed, Castiglione presents the principle as a *regula universalissima*, a real metanorm of behavior for all activities. *Grace* must inform every aspect of a gentleman's life, his "gestures, dresses, in the end all his movements"; it is "the dressing of everything" and as such it must be present in "everything one does or says." In order to clarify the concept of *sprezzatura*, Castiglione employs it in relation to single "arts" in the modern sense, that is, fine arts. As regards dancing, "a single step, a single movement of the person that is graceful and not forced, soon shows the knowledge of the dancer"; a musician "who in singing utters a single note ending with sweet tone in a little group of four notes with such ease as to seem spontaneous, shows by that single touch that he can do much more than he is doing," and, more generally, one must avoid sequences of perfect consonances without also inserting dissonances, to

avoid "a too affected harmony";[6] often in painting "a single line not laboured, a single brush-stroke easily drawn, so that it seems as if the hand moves unbidden to its aim according to the painter's wish, without being guided by care or any skill, clearly reveals the excellence of the craftsman."[7] In addition to these examples about "artistic" activities, we find many other remarks about everyday practices, those in which the aesthetic aspect does not at all prevail. Horsemanship is an example: "You see how ungraceful a rider is who strives to sit bolt upright in the saddle . . . as compared with another who seems not to be thinking about it, and sits his horse as free and steady as if he were afoot." Or the handling of weapons: "here is a man who handles weapons, either about to throw a dart or holding a sword in his hand or other weapon; if he nimbly and without thinking puts himself in an attitude of readiness, with such ease that his body and all his members seem to fall into that posture naturally and quite without effort,—although he does no more, he will prove himself to everyone to be perfect in that exercise."[8] Or also in one's way of speaking, which must be incisive and elegant, easy, rich, and well arranged, without being overrefined, so to "make it seem as if nature herself were speaking."[9]

In general, the rule of *sprezzatura* holds in every aspect of one's *public* conduct, and applies to any situation in which a *social* dimension is involved. It is a ubiquitous norm informing one's relationships with others. Grace can in fact be appreciated only in society, for only when one can be *observed* and *judged* by others does *sprezzatura* become the founding principle of a gentleman's or a lady's behavior. Here emerges the *lato sensu* "political" dimension of art concealment: we should not forget indeed that grace is necessary above all to gain the favor of the prince. The whole conduct of the courtier is in fact aimed at gaining the favor both of the other courtiers and of the lord. This difficult

task makes it necessary to possess not only good qualities, but also the capacity to "exhibit" them *nonchalantly*, so to avoid suspicion or envy. Being a politician, the courtier is precluded from any kind of spontaneity. Naturalness is always for him a by-product, something pretended; skills and dexterity are in turn concealed by dissemblance.

This opens up a wide range of possible applications of the *ars est celare artem* principle. It is well known indeed that the two terms *pretense* (or simulation) and *dissemblance* (or dissimulation) gained a pivotal role in sixteenth- and especially seventeenth-century reflection. For a period of approximately two centuries, from the famous chapter 18 of Machiavelli's *Prince* ("But it is necessary to know well how to color this nature, and to be a great pretender and dissembler") to the *Breviario dei politici* attributed to Cardinal Mazzarino ("Ancient philosophers reduced their philosophy to the two following maxims: endure, and abstain. Politicians too reduce their profession to two maxims: simulate, and dissimulate"), the theme of the necessity of simulation in politics seems to have been inescapable for almost every thinker who addressed the question of human coexistence. From Montaigne to Giordano Bruno, from Grotius to Justus Lipsius, from Botero to Bacon, each felt the urgency of this theme.[10] Jon Snyder, a scholar who built his own research around the relation between aesthetics and politics in the sixteenth century, has suggested that deception, or simulation, is but another name for *sprezzatura*.[11]

Snyder's proposed taxonomy is indeed a very promising lead, inviting us to a deeper inquiry. It is evident, for example, that, in epochs of religious conflict, the dissimulation of one's own faith adopted by the various religious minorities, which was aimed at defending them from the persecutions perpetrated by the dominant confessions (what is known as *nicodemism*), is

something completely different from the *nonchalant* (*sprezzato*) behavior of the courtier.[12] To put this idea in logical terms, it may be said that *sprezzatura* and dissimulation (*dissimulazione*) are not fully synonymous because, even if showing a *nonchalant* attitude is a form of simulation, not every form of simulation is compatible with *sprezzatura*. Moreover, if it is true that one simulates what one is not and dissimulates what one actually is—that is, if we distinguish simulation from dissimulation— we will notice that *sprezzatura* is a form of *dissimulation* rather than of *simulation*. This puts us in the position of recovering a connection between our theme and some of the most interesting seventeenth-century reflections on it. In that century, which not by chance has been called the century of simulation, many authors (and above all the Apulian Torquato Accetto) in some way defended the practice of dissimulation, which they distinguished from the always-reprehensible simulation. It thus becomes clear how Botero, for example, could define *dissimulation* in terms reminiscent of the principal features of *sprezzatura*: "it is called dissimulation, the act of concealing what one knows, cares about, does, and appreciates."

We might then say that one simulates what one is not, and dissimulates what one actually is. For example, Machiavelli's prince feigns fraternity and loyalty with the aim of concealing his own willingness to betray. But faking the possession of moral qualities has nothing in common with having *sprezzatura*, which is always relative to the concealment of *positive* qualities or skills (it is the concealment of an *art*, after all). The distinction is subtle, but it should nonetheless be maintained. For example, a true gentleman should take care of not making others envious through the ostentation of his abilities. Dealing with someone more powerful than us is always dangerous, because a powerful person will never let someone of inferior social class and authority eclipse her. Thus carefulness and hence dissimulation are

necessary to avoid offending the powerful or irritating with an ostentatious display of one's capacities.

Obviously, this distinction is not always clear in the literature about life in the court. Often, also because of the quick transformations and degeneration of the conditions of political life, only the necessity of a generic pretense in social affairs has been emphasized, without any account of the distinction between simulation and dissimulation.[13] Thus, in Philibert de Vienne's *Philosophe de court*, a treatise from 1547 that offers a sort of satirical praise (more than a reformulation) of Castiglione's themes, the final chapter concerns grace, and develops a substantial assimilation of *bonne grace* to simulation, with the addition of disapproval for candid and honest conduct: "*Au contraire, estre ouvert et simple appartient aux bestes et nyais. Car, estant ceste presumption entre nous que, il trompe qui peult, ceuz qui, d'un coeur ouvert, se declarent et mostrent ne vouloir user de fraude, sont reputez ignorans et n'ayant pas l'esprit de parler à un homme.*"[14] In this climate made of mutual and constant deceits one must always be vigilant, and feigning becomes a sad necessity.

For example, it would be very dangerous to banish flattery from society. By banishing flattery we would also waive decency, because, as Stefano Guazzo says in *The Art of Conversation*, "we should not salute any man, whom we suppose to be secretly our enemy; but as it is, he very complaisantly gives us the time of the day, though in his heart he may wish us all the mischief possible. But what will you have a man do? We must even imitate them, look pleasantly, and stare in their faces; we must play the fox among foxes, and *countermine art with art.*"[15] Here the variation on the theme of *artem celare* seems more affected by old sayings like *vulpinari cum vulpe* ("you have to outfox the fox") or *ars deluditur arte* ("trickery foiled by a trick," quoted in the *Disticha Catonis* or by Francesco Guicciardini when he says *l'arte deludersi con l'arte*), than by the subtleties of *sprezzatura*.

On the contrary, in Tasso's dialogue *Il Malpiglio: A Dialogue on the Court*, the connection between dissimulation and the good qualities of the gentleman is clearly stated: "every superiority in wit is usually hated by the prince: when present, the courtier, as he often does, should hide it behind a veil of modesty rather than display it with pride." By concealing his own qualities, the courtier "dodges the boredom of the prince, and by hiding them further he might be able to avoid the envy of the court." The connection between Tasso's advice and the theme of *sprezzatura* becomes obvious when he introduces a parallel, which sounds familiar to us, with the art of painting: a gentleman's virtues "do not display in equal manners or at all, but as in painting what is distant can be either outlined by a few shadows or most lively rendered by the use of colors, so with the virtues of prudence, strength, magnanimity, and some others they are only outlined and unfold from a distance."[16]

But perhaps the one who stressed the distinction between *simulation* and *dissimulation* the most is Torquato Accetto, who in 1641 published *Della dissimulazione onesta* (*On Honest Dissimulation*), a short treatise rediscovered by Benedetto Croce in the twentieth century. Dissimulation is not fraud, but rather "a deceit that has something to it," aimed at defending oneself against the "unjust power." Dissimulation is thus staged to defend rather than to offend. After all, dissimulation doesn't involve stating or doing what is false, "being anything but a veil made of darkness and violent deference, from which it does not derive the false, but rather the true is given rest, so to demonstrate it at due time." The world is so treacherous that even the *vulpinari cum vulpe* may be insufficient:

> But foxes are many among us and often unknown and, when we recognize them, it is hard to use art against art. In this case the

one will be wise who succeeds in appearing simple, because pretending to believe those who want to feign us is the way to make others believe whatever we want them to believe; and it is a sign of great intelligence to appear blind right there where one can see most properly.

What is beauty in fact, Accetto asks, if not a form of dissimulation? Not, however, in the sense that one would expect, but because, just like the rose dissimulates its transience, so a beautiful young woman (and, to be fair, this image could only have come out of a seventeenth-century man's mind) is nothing but a "corpse dissimulated by the prime of life." The more they are dissimulated, the more beautiful they are, so that dissimulation can be said to be the virtue that is the condition of any other virtue. Accetto recalls the argument in favor of *sprezzatura*:

> The head wearing an undeserved crown is suspicious of any head in which some wisdom resides; thus often the dissimulation of virtue is a virtue above virtues, though not through the veil of vice, but rather overshadowing some of its rays, so that the envy's feeble sight and fear of the others are not irritated.

Accetto is also well aware of the inevitably paradoxical character of dissimulation: "if any other thing is favored by its continuous practice, in dissimulation we experience the contrary, because it seems to me that one could not succeed in constantly dissimulating." The one who *always* acts like a dissimulator is wrong, because she makes it easy to call the bluff. "Dissimulation is a profession that cannot be professed."[17] Because, as Rabelais knew only too well, "subtlety suspected, subtlety foreseen, subtlety found out, loses the essence and very name of subtlety."[18] Therefore, even those aiming at explicitly praising dissimulation

could not succeed if not through dissimulation itself: at the be-
ginning of his treatise, almost putting *en abîme* dissimulation,
Accetto warns us that dissimulation is not only the object of his
book, but also its very style, "because writing about dissimula-
tion requires dissimulation also on the part of the writer, and
thus a lot of what I have initially written has been cut in the
final version"; and in the conclusion he writes: "I'd be glad to
express all my gratitude for the benefits you have bestowed upon
me; but I shall not give thanks to you, because I would offend
your laws if I would not dissimulate how much, with reason, I
have dissimulated."

The universality and the political character of the principle
of *artem celare* were clear to Baltasar Gracián, the most impor-
tant Spanish theorist of court life, who rephrases Castiglione's
sprezzatura in terms of *despejo* (ease, grace), and largely praises
it in *El Héroe* (*el despejo, alma de toda prenda, vida de toda perfec-
ción, gallardía de las acciones, gracia de las palabras, y hecizo de todo
buen gusto*) and later in *The Art of Worldly Wisdom*:

> Grace in everything. It is the life of talents, the breath of speech,
> the soul of action, and the ornament of ornament. Perfections are
> the adornment of our nature, but this is the adornment of perfec-
> tion itself. It shows itself even in the thoughts. It is most a gift of
> nature and owes least to education; it even triumphs over train-
> ing. It is more than ease, approaches the free and easy, gets over
> embarrassment, and adds the finishing touch of perfection.
> Without it beauty is lifeless, graciousness ungraceful: it surpasses
> valour, discretion, prudence, even majesty itself. It is a short way
> to dispatch and an easy escape from embarrassment.[19]

The great enemy of *despejo* is of course *affectation*. Any dis-
play, any manifestation of skills is particularly dangerous be-
cause it allows the adversary to take countermeasures and act

accordingly. The real political capacity lies in the concealment of one's own capacities.

> Por huir la afectación dan otros en el centro de ella, pues afecten el no afectar. Afectó Tiberio el disimular, pero non supo disimular. Consiste el mayor primor de un arte en desmentirlo, y el mayor artificio, ed encubrirlo con otro mayor.[20]

This passage is echoed in the *Art of Worldly Wisdom*:

> Man's life is a warfare against the malice of men. Sagacity fights with strategic changes of intention: it never does what it threatens, it aims only at escaping notice. It aims in the air with dexterity and strikes home in an unexpected direction, always seeking to conceal its game. It lets a purpose appear in order to attract the opponent's attention, but then turns round and conquers by the unexpected. But a penetrating intelligence anticipates this by watchfulness and lurks in ambush. It always understands the opposite of what the opponent wishes it to understand, and recognizes every feint of guile. It lets the first impulse pass by and waits for the second, or even the third. Sagacity now rises to higher flights on seeing its artifice foreseen, and tries to deceive by truth itself, changes its game in order to change its deceit, and cheats by not cheating, and founds deception on the greatest candour.[21]

The more skilled we are, the more we must conceal our skillfulness, so to keep others from being envious and capable to assess the actual range of our virtues:

> One always feels sure that the man who affects a virtue has it not. The more pains you take with a thing, the more should you conceal them, so that it may appear to arise spontaneously from

your own natural character. Do not, however, in avoiding affectation fall into it by affecting to be unaffected. The sage never seems to know his own merits, for only by not noticing them can you call others' attention to them. He is twice great who has all the perfections in the opinion of all except of himself; he attains applause by two opposite paths.[22]

Gracián is well aware that the original application of the principle of *artem celare* pertains to aesthetics. This clearly emerges from the passage at the beginning of *The Art of Wordly Wisdom* in which he writes that "the wise man dissimulates one's advantages, in the way in which usually beauty is concealed by means of carelessness"; yet this is not his focus of interest, it being the social function of *despejo*. And in La Rochefoucauld's *Maxims* we can find both the strictly aesthetic and the behavioral meaning of the concealment of art. The first one is theorized in the *Discours sur le réflexiones ou sentences et maximes morales* that opens the edition from 1665.[23] The author apologizes as his text lacks the necessary ordered structure and art, and adds as justification the fact that a work written for the author himself cannot follow the same rules of a professional work. Moreover, "this disorder has its own virtues, which art cannot imitate." I will always prefer, he adds, "the neglected style of writing of a courtesan having the awkward regularity of a professor only acquainted with his own books. *The more what he says and writes looks easy, and has a certain air of carelessness to it, the more this negligence, which conceals art behind a simple and natural expression, makes it enchanting.*" This statement of poetics was supported by the authority of Torquato Tasso, whose famous lines about Armida's garden are quoted both in Italian and in a French version:

l'artifice n'a point de part
dans cette admirable structure;

la nature, en formant tous les traits au hasard,
sait si bien imiter la justesse de l'art
que l'oeil, trompé d'une douce imposture,
croit que c'est l'art qui suit l'ordre de la nature.

In the corpus of *Maxims*, though, as expected, the focus is all on the "political" meaning of *artem celare*. "Affected simplicity is refined imposture"; "The most deceitful persons spend their lives in blaming deceit, so as to use it on some big occasion to promote some great interest." Real cleverness, as Descartes writes in a private letter, "consists in never showing to be clever," and La Rochefoucauld says exactly the same: "there is great ability in knowing how to conceal one's ability." As a consequence, it becomes impossible, in society, to judge whether a behavior is *really* spontaneous or only pretends to be: "If one acts rightly and honestly, it is difficult to decide whether it is the effect of integrity or skill."[24] One century later, Chamfort will definitively exclude even this latter possibility:

> The ugly truth, one that however needs to be acknowledged, is that in society, and in particular in high society, all is art, science, calculation, even the appearance of simplicity and of the most amiable easiness. I have seen men in whom what looked like the grace of an instinctive movement was in truth a construction, indeed quite timely and yet extremely skilled and learned. I witnessed the almost-perfect matching of the most pondered calculation with the apparent spontaneity of the most inattentive neglect. It is the competent *négligé* [*le négligé savant*] of the *coquette*, from which art banished everything that resembles art. Regrettable, but necessary. . . . It seems impossible that, in actual society (I am here referring to the high society), there is even one single person who can afford to disclose the depths of her soul or the features of her character, and above all her weaknesses,

to her best friend. But, once again, in this way we have to nurture one's skills accordingly, in a way that shall raise no suspect, if only not to be despised as actors of a company of excellent comedians.[25]

Leopardi is of the same opinion: "Artifice is so necessary in living with men that even sincerity and frankness must be used with artifice."[26] This is thus the last passage of the long journey covered so far, in which we progressed from the *neglegentia diligens* of the good orator to the *négligé savant* of the *coquette*, and from the noble dealings of gentlemen that Castiglione wanted to regulate to the treacherous scene of the social life in which everyone is a potential enemy who has to be skillfully deceived without being noticed.

However, the rule of art concealment theorized in the *Courtier* may have less cynical and distressing consequences, if, even in the context of social conduct, one does not take into account its explicitly political, "Machiavellian" dimension, but rather focuses on the private sphere of good manners. In this case, *Sprezzatura*, *despejo*, ease, and discretion all represent anticipations of the modern concept of *tact*. *Tact* can be clearly defined if we consider its dialectical relation to etiquette, or the code of good manners. Actually, one can be well mannered and at the same time have no tact, lacking the capacity to perceive whether something fits a particular circumstance or not, or when it is appropriate to respect certain norms or not. While in closed, strictly traditional societies (as happens in many primitive cultures or in highly hierarchical societies) behaviors tend to conform to ceremonies or ritual protocols in which exceptions are not admitted, more open societies tolerate, or even require, a flexible application of the norms of etiquette. Limiting one's behavior to a servile or uncritical application of the norms of etiquette is anything but good-mannered, since being able to

attune to circumstances is an essential part of having good manners. Therefore, as La Bruyère writes, "we may define all the essentials of politeness, but we cannot determine how and where they should be used."[27] While it is not necessary to have a new rule for applying the rules, a new kind of insight is needed to know whether the rule should be applied or not. This form of discernment coincides with Guicciardini's *discrezione* (discretion) ("rules are learned from books; and exceptions are learned from discretion"), Gracián's *despejo*, and Castiglione's *bon giudicio* (good judgment) ("I think it is quite enough to say that the courtier should have good judgment; . . . and this being so, I think that without other precepts he ought to be able to use what he knows seasonably and in a well bred way. To try to reduce this to more exact rules would be too difficult and perhaps superfluous").[28] Amelot de la Houssaye translates into French Gracián's *despejo* with the locution *je ne sais quoi* (I don't know what), perhaps conditioned in this by the fact that in French literature on good manners and court life the essential qualities of the perfect gentleman are usually singled out as *je ne sais quoi*. This is confirmed by Mademoiselle de Scudéry when she reminds us that it is a disgrace not to posses the *je ne sais quoi*:

> Hence it is true that nothing in one's spirit is more appealing than this gallant and natural attitude, which knows how to add the *je ne sais quoi* that turns the most unpleasant things pleasant, and that invests conversations with a secret satisfying and entertaining charm; in other words, this gallant *je ne sais quoi*, permeating those who carry it in their spirit, actions, and even dresses, is what completes decent persons and makes them lovable and loved.[29]

If that is so, then to affirm that art must be concealed in everyday conduct can also mean that social conduct should not be overconditioned by a rigid acceptance of the formal norms of

bon ton; it should not be ceremonial or mechanical, but rather appear detached, easy, free, and independent in spirit. The upbringing of a perfect gentleman must be effortless and flexible, as reminded by Marcel Proust in *In Search of Lost Time*:

> From the first Saint-Loup made a conquest of my grandmother, not only by the incessant kindness which he went out of his way to show to us both, but by the naturalness which he put into it as into everything else. For naturalness—doubtless because through the artifice of man it allows a feeling of nature to permeate—was the quality which my grandmother preferred to all others, whether in gardens, where she did not like there to be, as in our Combray garden, too formal flower-beds, or in cooking, where she detested those dressed-up dishes in which you can hardly detect the foodstuffs that have gone to make them, or in piano-playing, which she did not like to be too finicking, too polished. . . . This naturalness she found and appreciated even in the clothes that Saint-Loup wore, of a loose elegance, with nothing "swagger" or "dressed-up" about them, no stiffness or starch. She appreciated this rich young man still more highly for the free and careless way that he had of living in luxury without "smelling of money," without giving himself airs.[30]

8

TRUE ELOQUENCE MOCKS ELOQUENCE

The frequency with which it is likely to come across the principle of *artem celare* in courtesy literature and political treatises must not lead us to forget how widespread the same principle is within the field of arts in the narrower, present-day sense of the word, that is, the fine arts. We saw already how easy it is to find occurrences of our principle at work in painting, in sculpture, and in the very special art of ornamental gardening. A look at sixteenth-, seventeenth-, and eighteenth-century treatises on poetics plainly proves how this idea did not lose ground even in the literary arts, and how it has been employed in this context as frequently as it has been in the visual arts.

At the beginning of the sixteenth century, Marco Girolamo Vida's poetics, composed the same year as the third edition of Baldassare Castiglione's *Courtier*, stated:

> Omnia sponte sua veniant, lateatque vagandi
> Illa cupido, potensque omne labor occulat artem[1]

At the end of the century, the *Apology for Poetry* by Philip Sidney, published in 1595, still made extensive use of the principle

of *artem celare*. Sidney, who certainly knew the English version of the *Courtier* translated by Sir Thomas Hoby, compares the chaste eloquence of *divers small-learned courtiers* to the excessive, hypertrophied one produced by *some professors of learning*:

> Undoubtedly (at least to my opinion undoubtedly) I have found in divers small-learned courtiers a more sound style than in some professors of learning; of which I can guess no other cause, but that the courtier following that which by practice he finds fittest to nature, therein, though he know it not, doth according to art—though not by art; where the other, using art to show art and not to hide art as in these cases he should do—flies from nature, and indeed abuses art.[2]

Cicero made extensive use of the figure of *repetition* when railing against Catiline, "do[ing] that artificially, which we see men in choler do naturally"; yet he was in a position to do this because the fact that he was *truly* enraged was quite plausible, while those who resort to such contrivances often obtain the opposite of the desired effect: "these men bringing in such a kind of eloquence, well may they obtain an opinion of a seeming fineness, but persuade few,—which should be the end of their fineness." Moreover, Sidney mentions the anecdote of Antonius and Crassus, who pretended to know no rhetoric at all (the same recalled in the *Cortegiano*), though his goal is to point out how even the expedient of appearing ignorant of the art at stake should be used with discretion, because, if used too often, the audience shall eventually find out that it is an artifice rather than the truth.

Although Sidney draws his examples from rhetoric, and seems to refer to it in the first place, it is clear that he has targeted mainly poetry. The idea of concealing art is particularly useful to him because it enables him to attack head-on what he

considers the major defects of the poetry of his time, namely, excessive sophistication, unwonted language, overelaborated selection of figures—in short, all those salient features of that tendency of English literature that goes by the name of "Euphuism" (after John Lyly's *Euphues*, the most representative work of this trend). In the literature of his time, written in verse as well as in prose, Sidney sees the sworn enemy of restrained carelessness, *ostentation*: "that honey-flowing matron eloquence appareled or rather disguised, in a courtesan-like painted affectation: one time with so farfet words, that many seem monsters, . . . another time with coursing of a letter, . . . another time with figures and flowers extremely winter-starved."³

More or less in the same period, Richard Puttenham's treatise on poetics, the *Art of English Poesie* (1589), also endorses the *artem celare* motto: "We doe allow our Courtly Poet to be a dissembler only in the subtilties of his arte: that is, when he is most artificiall, so to disguise and cloake it as it may not appeare, nor seeme to proceede from him by any studie or trade of rules, but to be his natural."⁴ In the following century, again within the English literary scene, John Dryden makes use of the same idea of concealing art in order to extol the poetic strength of his friend Robert Howard:

> Either your Art hides Art, as Stoicks feign
> Then least to feel, when more they suffer pain . . .
> Or it is Fortune's work . . .
> Sure that's not all:
> This is a piece too fair
> To be the child of Chance and not of Care.⁵

One may glimpse in these words an echo of the passage from Horace's *Epistles* where, regarding the poet, it is said that *ludentis*

speciem dabit, et torquebitur, that is, that the poet will look like one who plays, and yet won't write without pain. This eventually introduces us to a variation on the principle of concealing art that one can express with the example of the poet who, beneath his apparent playfulness of style, hides his real suffering so to present to us, as Baudelaire put it later, *un rire trempé de pleurs qu'on ne voit pas* (a laughter wet with tears that people do not see).[6]

Returning to the traditional meaning of our rule, we should point out that it can be found in the works of both the baroque author Daniello Bartoli and the classicist Boileau. As far as the Jesuit from Ferrara is concerned, here are two excerpts to which the Italian critic Luciano Anceschi drew our attention: "because delicate art of most refined taste has to be properly concealed beneath enough naturalness, such that what is said should not appear a product from ingenuity, a contrived gesture, but something like the impulses of the heart venting in speech"; "when art serves no better purpose than to bring up nature more than itself, it passes for nature itself, and we have art in its higher perfection."[7] Regarding the French man of letters, not by accident a sharp commentator of the ancient treatise on the sublime (see especially the tenth reflection in *Réflexions critiques sur Longin*), we can cite two passages from *Art poétique*. In the first canto, among the general precepts we read:

> Prenez mieux votre ton. Soyez simple avec art
> Sublime sans orgueil, agréable sans fard.

In the second, with particular reference to the ode form:

> Son style impétueux souvent marche au hasard.
> Chez elle un beau désordre est un effet de l'art.[8]

Among the theorists of classicism, in Italy both Gianvincenzo Gravina and Ludovico Antonio Muratori eventually endorsed the *artem celare* principle. At the very beginning of the *Ragion poetica*, Gravina claims that we should not consider a model of perfect artistry "those who have art written all over their face and have more desire to flaunt the fervor of their imagination and insight of their study than really take us to their expression." He argues:

> Hence, poets understandably should not show themselves so artificial to disclose their skill in composing each line perfectly, because one has to hide the device under the shade of the natural, and it is profitable now and again to use one's wits in order to impress the features of carelessness on verse, so that the fancy of believing fiction real does not fade away over the pressure of manifest artifice, which is indication of contrivance, and parades one's flamboyant learning, which obscures natural manners.[9]

In the same way, a few years before, Muratori, in *Della perfetta poesia italiana*, insisted that genuine taste is that which is capable of appreciating concealed art: "But who is endowed with the most refined Taste cherishes the modest and disguised art the most, which paints the Truth of Nature with its own light, and without pomposity [rather] than the ambitious labour, and subtlety of the ingenuity of others," and this is because

> the sole Truth of Nature set by the poet with his natural light employing the most exquisite artifice is that which delights us powerfully, which enchants us and compels us to confess that the poet is all at once most ingenious when he works to conceal his own ingenuity, much art being difficult and therefore more

admirable and more worthy of praise when the artist pretends that the work has been made using an art without artifice.[10]

When we take stock of the figures just mentioned (Boileau, Muratori, Gravina) together with those we encountered in the chapter in which we dealt with the visual arts (Bellori, Mengs, Caylus, Spalletti, Milizia), it is natural to point out how successfully the principle of *artem celare* is demonstrated within the domain of neoclassical poetics. Broadly speaking, we can affirm that the idea of hiding art is particularly suited to classical tendencies and those stances that invoke classicism: it appears in fact to yield full expression on the one hand to the hypostasis of classicality as a kind of *art without artistry*, an art that by virtue of its perfection is suitable for being considered as *true nature*— remember Winckelmann's firm belief according to which one can attain authentic naturalness and spontaneity only through the imitation of antiquity—and on the other hand to the sharp opposition exerted by classicism and neoclassicism to mannerism and the baroque, understood as a poetics of *ostentation*, of manifest and flaunted artifice.[11]

This conclusion, which privileges the connection between *artem celare* and neoclassicism, although historically sound, runs the risk of overshadowing a crucial aspect of the story that I have been unfolding in this work. I have here in mind not so much the fact, though indubitable, that occurrences of the precept to hide art also emerged in those authors who can be enrolled in anything but the ranks of classicism in any of its form, or the fact that invitations to conceal art can also be found in the nineteenth and twentieth centuries. Instead, I want to point to something else that needs to be brought to the foreground. What needs to be stressed, as occasionally shown in its historical evolution and

more decidedly at the time under consideration, is that in the eighteenth century the principle of *artem celare* turns from a technical, limited rule into a general aesthetic principle. We are no longer facing a specific technical principle, at work *inside* the techniques to which it applies, but rather a principle that, while active and pervasive in various aspects of human behavior, does emerge quite clearly as pursued independently and, so to speak, for no other purposes in artistic activities. The *fine arts* place us in a position to identify and understand it as an application of the law of creativity, which does not end itself in art but rather becomes primarily manifest in art. A creative component is in fact present in the most diverse activities: it unsettles a habitual need for the good, it confers a lively character to a conversation, it helps the accomplishment and satisfaction of a practical action, and it can yield an elegant scientific demonstration— but this component would remain hidden if there were no such thing as art to disclose it.

What allows the identification of the principle of *artem celare* as an autonomous principle of creativity is thus a far-from-obvious reflection on the meaning of the word *art* in such a formula, or, better said, in the *twofold* sense in which the word *art* appears. Its use in the field of rhetoric is once again helpful to address this seminal question. When we dealt with the rhetorical use of the principle of *artem celare* in antiquity, we noticed how such a principle never comes to the point of undermining reliance on the effectiveness of rhetorical *rules*, unless maybe in some passages of the pseudo-Longinian treatise. Hiding art is a rule, and there are those that recommend the use of rhetorical figures or oversee their formulation. The formula *pars est eloquentiae eloquentiam abscondere* is, in this sense, crystal clear: to hide one's artifice is itself an artifice on a par with other artifices; it is just

a further rule that belongs to the same apparatus of rules. As the validity of rules is never to be questioned, so the validity of rhetoric as a whole should never be doubted.

Yet, in the period under consideration it has been increasingly the case that rhetoric, as such, was in question, thought of as a stock of artifices. Not only did the excessive use of rhetorical devices fall into disgrace, but the very possibility of resorting to them did so as well, as every codified precept moves away from the only value that speech must possess, its naturalness. With the concealment of art, therefore, one may express not so much the desire to escape any ostentation, but rather a certain diffidence toward rhetoric as a whole, a yearning for an eloquence hinged on the capacity to adapt to circumstances. "This art," Antoine Gombaud, knight of Méré, writes in his *Conversations* (1668–69), "is small beer, at least the way it is taught." Those who codified its rules have done nothing but notice how some devices have been successful sometimes, and elevate them to general rules; but precisely for this reason those rules, far from applicable in every case, are such that they can, indeed must, be broken every time that the quality of one's interlocutors, the opportunity, or the particular moment suggest to do so, or merely when one succeeds in getting something better. After having mentioned once again Tasso's verse about Armida's garden, Méré goes on:

> The good art which makes sure that one is outstanding in speaking manifests itself solely under a natural seeming; it likes only plain and unsophisticated beauty; and although it works to put its ornaments under the right light, its main concern is to remain hidden. . . . I believe that the most perfect art is that which reveals itself as little as possible, and when, in a certain work, study and art are well noticeable, we can gather that those who claimed

to have both of them haven't either, or they don't know how to use them.[12]

One can be attractive and even charming without saying anything, said Méré, because "silence itself, in some cases, is revealing."[13]

In his *Dialogues sur l'éloquence*, Fénelon goes as far as saying, "The entire art of the good orator consists only in observing what nature does when she is not hampered." The *Dialogues* indeed revolve around the antithesis between two kinds of eloquence, one aiming to delight, the other to persuade: hence, the contrast between the flowery and effeminate Isocratean eloquence and Demosthenes's eloquence, where "it is nature herself who speaks in his ecstasy—the art is so perfect that it does not appear anywhere," or the praise of Virgil and Homer:

> Yet you will not find in them what are called conceits. Theirs are unpretentious things; nature shows herself throughout; and throughout art carefully conceals herself. You do not find there a single word which appears to be put in to plume up the poet's wit. He stakes his reputation upon not appearing at all . . . as a painter aspires to put before your eyes forests, mountains, rivers . . . without your being able to take notice of the strokes of his brush. Art is clumsy and contemptible whenever it makes itself visible.[14]

The thinker who gave the most careful consideration to the issues related to eloquence and the art of persuasion, and who spoke most clearly about the matter, was indeed a friend of Méré, namely, Blaise Pascal. Among his *Thoughts*, we find one that reads simply: "*La vraie éloquence se moque de l'éloquence*" ("true eloquence makes fun of eloquence"). What strikes us in this sentence is its succinctness and extreme keenness: we are bewildered

as if facing a paradox. But we can immediately notice how the pattern of Pascalian thought is in all respects identical with that exemplified by the maxim of *ars est celare artem*. What do these two statements have in common? They share the fact—also reminiscent of more celebrated statements like the Socratic "I know that I do not know"—that they take the form of statements that according to rhetoric prompt dissociation. Perelman and Olbrechts-Tyteca, authors of *The New Rhetoric: A Treatise on Argumentation*, claim that, when we run into an oxymoron or a tautology ("a young old man," "a man is a man"), "we cannot avoid a dissociation of notions if we have regard, as is usual, to both the meaning and the coherence of the thought expressed. There are expressions which invite us to dissociate a notion without specifying in what manner the dissociation is to be effected."[15] Facing the Socratic "I know that I do not know," in order to make sense of the paradox, we must attach different meanings to "knowing" in the first and the second occurrence of the word.[16] We should stretch the two senses of the word to their limits so to obtain, put in rhetorical jargon, an *antanaclasis* or *reflexio* in which each of the two parts of a sentence attaches a different meaning to the same word, as when in a dialogue a subject responds to her interlocutor by distorting, to her own profit, the meaning of the phrase used by her interlocutor.[17]

The same holds for *la vraie éloquence se moque de l'éloquence*: the eloquence that mocks eloquence cannot be the same eloquence one is making fun of, if we want the sentence to make any sense at all. Eloquence* will be natural, spontaneous, arising from things themselves rather than art eloquence, while eloquence** will be eloquence understood as that available knowledge from which one has to draw. Eloquence* will consist in the ability to manage rules, to decide on their application or even on their suspension; eloquence** will consist in rhetoric as a set of

adopted rules, already laid down according to a list. The first one may be the eloquence of establishing rules (as Méré seemed to suggest), that is, the eloquence of rules *in the making*, while the second one may be the eloquence of rules *once made*.

Pascal seems to have in mind something like this when he adds to his explanation a parallel with morality: "True eloquence makes fun of eloquence, true morality makes fun of morality; that is to say, the morality of the judgment, which has no rules, makes fun of the morality of the intellect."[18] The morality of the intellect is the situational, narrow-minded morality that decides on the basis of codified rules; the morality of the judgment decides on the individual case, well aware of the endless diversity of situations in which we find ourselves acting, of which Pascal goes as far as to say that it is indeed "without rules." The morality of the intellect is the opposite of the morality of sentiment as the esprit de géométrie is the opposite of the esprit de finesse. All these terms have stratified layers of meaning, since as a matter of fact Pascalian finesse is a kind of insight, of discretion, in the sense of Castiglione's *sprezzatura* and of Gracián's *despejo* (and indeed it is the chief quality of the honnête homme); similarly, intellect and judgment witnessed a separation leading up to Kant's distinction between intellect and the power of judgment (according to him, as is well known, the power of judgment will be primarily the aesthetic power of judgment); finally, as a matter of fact, sentiment is the new term coined by seventeenth- and eighteenth-century philosophers to denote the site of moral and aesthetical activity (where moral sentiment and aesthetic sentiment arise together).

In the case of *ars est celare artem*, we obviously need to perform an analogous operation, and separate the meanings of the two occurrences of *ars*. Hiding-art* cannot be the same thing as hidden-art**. To state what the latter is should, at this point,

be quite easy. Art**, the art that needs to be hidden, is art understood as a set of rules that can be made explicit and communicable, a technical and malleable "know-how." But now, what is art*, that is, hiding-art? Art* is art understood as the principle of creativity and organization; it is the *aesthetic principle* that decides the applicability of the rules of the arts**. Art* is art understood as *rule-changing creativity*, not merely as *rule-governed creativity*.[19] If so, a significant correspondence will come into view. Art** is art in the ancient sense of the word, that is, art as *techne*, knowledge codified according to rules, which can be (and in fact is) taught as a profession. It is art as Aristotle understood it (*ékxis tis metà logou alethoús poietiké, habitus cum recta ratione factivus*), namely, art as a productive tendency associated with a well-founded knowledge. This art is obviously not what we would call art, but is rather art as *craft* (the Italian word is *artigianato*, whose etymology refers to the traditional sense of art as a technique). This should not come as a surprise, since what we have seen throughout the book is the *ars est celare artem* precept applied to a wide variety of arts (or, better, techniques in the ancient acceptation of the term), from etiquette to archery, from rhetoric to cosmetics: all arts or techniques in the Greek acceptation of the term.

If this is the case, then it won't be hard to see that art*—hiding-art—will be art in the modern aesthetic sense, customarily labeled as "fine," precisely in order to distinguish it from craft, which is eventually what we take to be art strictly speaking. This art has no rules, or, at least, no rules that can be made fully explicit, and certainly no rules that cannot be communicated like those pertaining to craft. The principle of creativity is what governs such an art, in the sense that it *creates* its own procedure and it does not restrict itself to its application. It is an art in which *innovation* becomes the overriding value: a

fake can be strikingly similar to the original, but it is infinitely less valuable (aesthetically and commercially), because it is an imitation and not an invention, and it is inventions that we value above all in art.

By framing the issue in these terms, however, we are perhaps overemphasizing the splitting of the two terms. After all, our principle reads, *ars est celare artem*, that is, it still holds together, though paradoxically, the two terms, whose understanding calls for a separation and a contrast. Art in the modern aesthetic sense does not extinguish entirely that crafty (artistic in the way of the ancients) component, which can still play an important role. One can (still) compose poetry by employing an elaborate metric or prose (and of course writing artistically in prose). One way to perform visual art could be by burning a piece of coal inside a room; another way, however, may be by painting a *pictura picta* like Francis Bacon or Lucian Freud. It is possible to create sculptures using an *objet trouvé* or rather doing as Manzù did and Mitoraj does. That is why we claimed that art* of hiding-art would be best explained in terms of an aesthetic principle or creativity factor. And this is because of a further reason, at least as good as the one just considered, if only from a different angle. The precept *ars est celare artem* states that there is a creative or productive component in many forms of human agency, even if they do not strictly qualify as art in the modern sense. A creative, that is, not merely applicative, component can in fact be found in the art of rhetoric as well as in demeanor. The limit of ancient theory lies precisely in its incapacity to appreciate this component but as one rule *on the same level of* all other rules.

Here lies the mismatch between a principle like *pars est eloquentiae eloquentiam abscondere* and the Pascalian formula that sets out true eloquence. It may well seem that they express the same content, and yet, as a matter of fact, the former, even

though formally sound, yields to a self-contradictory statement (how could one part hide the whole?), while the latter, despite its paradoxical character or maybe in virtue of it, signals how the principle deciding on the applicability of rules cannot be one rule on the same level of the rules it decides upon. It is thus no coincidence that aesthetics as an independent philosophical field of research came into existence during the seventeenth and the eighteenth centuries, precisely by acknowledging such a principle of creative organization and giving itself the formidable and bold task of legitimizing what epitomizes a quite subversive kind of principle, that is, ascribing rational status to what apparently is unpredictable, and conveying what seemed helplessly locked inside one's subjectivity. Aesthetics felt entitled to do so because a condition of creativity did emerge in art in the modern understanding of the term, and it became the main reason for the existence of art itself. Guided in this way by art, aesthetics was able to trace the presence of the principle mentioned earlier of creative organization even within domains that are not "artistic" in our modern sense.

This process can be detected especially within that tendency that is known as the aesthetics of *délicatesse*. In France, its main exponents were Bouhours and Dubos, but it exerted its influence also on Montesquieu and others; outside France, Leibniz in Germany, Shaftesbury and Addison in England, and even Vico in Italy exhibited close affinity to the aesthetics of delicacy.[20] The distinguishing traits of this aesthetics are in fact its opposition to rationalism, its refusal to reduce aesthetic judgment to intellectual judgment, and therefore its denial of the possibility in the aesthetical domain of decisions that can be taken on the grounds of rules fixed in advance. *Discretion*, *sentiment*, *taste*, *grace*, *imagination*: all these words play a key role in such an aesthetics. But the name finally chosen to refer to that condition of creativity is

rather a quasi-term, a no-name, the very consequence of its namelessness: in fact, the aesthetics of *délicatesse* chooses to denote its aesthetic principle as *un je ne sais quoi*, I don't know what. To play with this definition, which admits its own powerlessness to further characterize its very object, does not require great wit. Nor does it consist in well-directed irony, since *non so che*, despite how poor the formula might sound (and perhaps is), historically played a very important function, which was not, as is often wrongly believed, that of anticipating Romanticism, but rather that of clearly denouncing (despite the nebulous character of the term) the impossibility of deciding, in the aesthetical domain, by appealing to objective criteria, concepts, measures, or proportions. This operation determined the twilight of a theory of aesthetics (and of art) two millennia old, and opened the way to modern aesthetics, whose common denominator is exactly the idea that beauty does not consist in an intrinsic quality.[21] For the purposes of our story, what is interesting to stress is that the theorists of *je ne sais quoi*, when in pain to give a definition of their tight-lipped formula, eventually end up drawing from the idea of *celare artem*. The first author to dedicate an entire text to *je ne sais quoi* (though the formula had been circulating for centuries) was Father Dominique Bouhours: in his *Entretiens d'Ariste et d'Eugène*, published in 1671, and in particular in the fifth of the six collected dialogues bearing the name of the precept, he introduces *je ne sais quoi* by comparing it to Gracián's *despejo*, which as we know is a translation and derivation of Castiglione's *sprezzatura*. Nor does it come as a surprise that Bouhours draws a similar connection, especially if we think that one of the French translators of Gracián's *The Art of Worldly Wisdom*, Amelot de La Houssaye, translated *despejo* as *je ne sais quoi*. Bouhours draws an interesting parallel with *concealed beauty*: "*Je ne sais quoi* and those beauties concealed behind a veil

behave similarly, in that they are most appreciated when least exposed to sight, and to which imagination is called for and adds something." Quoting Tasso, he speaks of "fine and hidden beauties," and finally refers to *artem celare* explicitly: "great masters too, who discovered that nothing is liked more in nature than what is liked without knowing precisely why, always tried to confer a certain allure to their works by concealing their art, with skill and artifice."[22] In the second *entretien*, Bouhours used the principle of art concealing in order to define *délicatesse*:

> Among the works of nature, the most elegant are those in which it prides to work minutely, and in which the almost imperceptible matter makes us doubt whether nature aims at showing or rather concealing its talents. . . . We can say, by analogy, that a thought blessed with elegance is characterized by this, that it is expressed with few words, and that its meaning is neither completely open nor pronounced: it looks like that it almost conceals it at least in part, encouraging us so seek it.[23]

The Spanish writer Benito Jerónimo Feijóo, in his *No sé qué*, collected in the sixth volume of *Teatro crítico universal*, published in 1734, insisted on the link between *non so che* and grace, a "concealed" grace that he aimed to reveal, quoting Apelles's anecdote that, after Castiglione, became, as we saw, a commonplace.[24] The idea of I don't know what as *natural grace* and invisible *charme* can be found in Montesquieu's *An Essay on Taste*, which he wrote for D'Alambert and Diderot's *Encyclopédie* late in his life, and which was published posthumously in 1757. Montesquieu applied the idea to what makes a person charming:

> The graces are more frequently centered in the mind, than expressed in the countenance. A beautiful face discloses at once all

its charms, and conceals nothing; but an amiable mind shows itself only by little and little, and at such times and in such a degree, as it thinks proper, it can conceal itself dexterously for a time, in order to shine forth afterwards with a brighter lustre, and to administer that kind of surprise, to which the graces often owe their existence. The graces are more rarely found in the features of the face, than in the air and manners; for these change every moment, and may therefore every moment produce new objects of surprise.[25]

Se cacher pour paroître, to hide oneself in order to stand out: this is the first of a series of paradoxes that Montesquieu tackles head-on. We face here the idea of the nonmanifest ornament, the absence of ornamentation that sometimes constitutes the most appreciated ornamentation. Montesquieu accounts for it by reference to the risks of affectation and ostentation, and to the fascination for simplicity: "as affectation and restraint are incapable of exciting surprise, it follows, that gracefulness is neither to be found in those manners that are under the fetters of restraint, nor in those that are the result of a laborious affectation; but in a certain ease and liberty that lies between these two extremes." This ease is, however, not an effortless spontaneity, but rather the painful result of study: "one would imagine, that those manners which are the most natural, should be the most easy in practice: but it is quite otherwise."[26]

We are not naturally spontaneous, but rather become so by strokes of effort. Setting a new paradoxical link in place, Montesquieu argues:

Nothing strikes us so agreeably in dress, as that negligence and even disorder which conceal the pains that have been taken, and keep out of sight all the art that cleanliness did not require,

and that vanity alone could employ. In the same manner wit is only agreeable when its sallies are flowing and easy, and seem rather luckily hit off, than laboriously invented and far-fetched. The man who amuses a company with smart sayings, which are the fruits of premeditation and study, will pass indeed for a man of wit, but not of that easy wit, which is the spontaneous effusion of nature, and in which alone the graces display their genuine charms. Grace in manners or in discourse appears most in those who are the least conscious of possessing it, and whose plainness and simplicity, promising nothing of that nature, occasion an agreeable surprise in such as at length perceive, in the midst of this simplicity, a quality which they so little expected. From all this we may conclude that the graces now under consideration are not to be acquired; in order to possess them we must be natural and ingenuous; and nothing is more self-contradictory than the attempt of studying to be natural.[27]

Rules, in art, have no absolute character. As both civil and penal laws can be better in abstract but result in injustice once applied, so artistic laws need to be constantly adapted to the peculiarity of the single work of art. This is a potentially anti-classicist principle, to which Gianbattista Marino gave expression in a private letter: "I think I know the rules better than the pedants all together: but the true rule is always to break rules at the right time and place." Montesquieu, though prudently affirming that all works of art have general rules to be followed as guides, says something similar in a formula closely resembling Pascal's *se moquer de l'éloquence*: "Nobody mastered art like Michelangelo; nobody mocked it like him."

A few years later, at the beginning of the nineteenth century, Joseph Joubert will establish a parallel between *je ne sais quoi* and *artem celare*: "The I don't know what, or the fascination for

it (in discourse, thoughts, style, and the like), is related to wonder. It consists in hiding art and the hand, and in a certain indecision in the symmetry and shapes, which can be appreciated without being noticed." As the Naiade hides her urn, the Nile its spring, so the author should conceal part of his thoughts and let the reader complete it and explore it.[28] But it will be Leopardi who will reprise Montesquieu's observation at most length. *Zibaldone* represents in fact a wealth of insights on *artem celare*. Leopardi refutes Montesquieu's account of *non so che* in terms of *surprise*, but he is also well conscious that naturalness is not enough:

> While naturalness is not the only source of grace, there cannot be grace where there is affectation. The fact is that although something may not be graceful on account of being natural, it cannot be graceful unless it is, or appears to be, natural, and the slightest sign of effort and calculation, etc., is enough to destroy all gracefulness.[29]

It is the appearance of ease that is attractive for us, rather than the exhibition of the overcome difficulties:

> Apart from the fact that effort detracts from the truth, because only naturalness is truthful, there is no wonder in your achieving what you wanted by making an effort. And there is not such wonder in your making something that you wished to make, as in your making it without others realizing that that was what you wished. It is not difficult to do something difficult with difficulty, it is difficult to make it look easy.[30]

Affectation is thus the true enemy, as it tires us, bores us, and irritates us, which *sprezzatura* successfully avoids.

Affectation usually begets uniformity. . . . Persistent affectation creates a uniformity all its own. Do not say that in this case constant naturalness must also result in uniformity. Naturalness does not stand or fatigue you, nor does it hit you in the eye, like affectation, . . . unless it is deliberate or contrived, in which case it is no longer naturalness but affectation. . . . It follows that an apparent ease and abandon, by allowing everything to flow naturally in writing (and in painting, etc.) will ensure variety and thus avoid the tedium induced by other qualities of the writing, etc., including e.g. elegance: since nothing is less tedious than nonchalance [*disinvoltura*].[31]

The ancients knew how to avoid affectation: differently from the moderns, they did not chase after the details showing off their research, niggling, chopping up, and dragging on for the sake of the effect, "all of which makes the intention obvious, destroys natural ease and unconcern, reveals art and affectation, and gives more space in the poem to the poet than to the thing he is talking about."[32]

For the moderns naturalness became incredibly difficult to reach, as we know that "Even negligence and carefreeness and nonchalance [*sprezzatura*], and even lack of affectation itself, can be affected, conspicuous, etc. Even simplicity naturalness spontaneity."[33]

This is where, according to Leopardi, the Romantic went wrong, that is, believing that naturalness can be pursued by appealing to spontaneity, to impetus, to what is primitive. Instead it can be recovered and gained through effort and study. Nature is not to be found at the beginning, but rather at the end, and spontaneity is, we might say, a second-order spontaneity, achieved

(and this is the crucial point) not *despite* but rather *thanks to* art. To repeat the words of Heinrich von Kleist (a Romantic thinker), spontaneity *is a knowledge that underwent the infinite*:

> Breme [Ludovico Di Breme] has forgotten that philosophical observation, old though it is, that the simplest, truest, and surest means are always the last that men discover, and so it is in the arts and the professions, as in the ordinary things of life, and in everything. And so the last thing achieved by someone who feels and wants to express the emotions of his heart, etc., is simplicity and naturalness, and the first thing is artifice and affectation, and someone who has not studied and has not read and is, as these people say, immune to the prejudices of art, and innocent, etc., certainly does not write with simplicity, but quite the opposite. We see in young children when they begin to compose: they do not write with simplicity and naturalness at all, for, if that were the case, the best writings would be those of children, whereas, on the contrary, one sees only exaggerations and affectations and refinements, albeit clumsy ones, and the simplicity that is there is not simplicity but childishness. You could say the same thing about certain popular songs, etc., which, in a certain sense, are simple, but put a little of that simplicity alongside Anacreon's, which seems unsurpassable, and see whether you think it can still be called simplicity. Hence the aim of art, which these people criticize, is not art at all but nature, and the height of art is naturalness and the concealment of art, which novices and the ignorant are unable to conceal, even though they have very little of it, but that very little shines through, and the cruder it is, the more nauseating. And Horace's nine years which Breme ridicules, were certainly not spent increasing the artifice of his writing, but in reducing it, or, rather, in increasing it in order to conceal

it, and in other words to come ever closer to nature, which is the aim of all those studies and those emendations, etc., which Breme mocks, which the Romantics mock, contradicting themselves, because, while they curse art and extol nature, they fail to realize that where there is less art, there is less nature.[34]

9

READY-MADES

The story is well known, so familiar that a quick overview will suffice. In 1913, Marcel Duchamp, after painting *Nude Descending a Staircase*, abandons painting. In the same year Duchamp mounts a bicycle fork with front wheel upside down on a wooden stool. He keeps it in his studio, saying that watching it spinning causes him the same pleasure as watching the flame of the fireplace. The following year he buys an iron bottle rack in a hardware store. Soon after moving to New York, he writes his sister Suzanne to give her directions to paint his name on the object, since he wanted to make it a piece of "readymade from a distance," as he did the previous year in America with a number of other objects. In fact, in 1915 he bought one of those snow shovels with a handle that ends with a grip and hung it in his studio with the saying "In Advance of the Broken Arm" painted on the handle as a joke, together with his signature. The following year he took a steel comb, one of those used to groom dogs' hair, and inscribed along the edge the absurd phrase "3 ou 4 gouttes de hauteur n'ont rien à faire avec la sauvagerie; M. D. Feb. 17 1916 11 a.m." Also, he fixed to the floor a wooden and metal coatrack and titled it *Trap*.

However, it was in 1917 that the definitive episode in this series took place. The Society of Independent Artists, just established in New York, organized an exhibition. In order to be able to participate and display one's work a contribution of six dollars was required, a small sum indeed. Duchamp, using a pseudonym, sent a porcelain urinal, one of those used in male public bathrooms, giving it the title *Fountain*, and signing it as R. Mutt together with the date. The object—the work—was not exhibited, nor was it included in the catalogue. It remained hidden in some forgotten recesses of the gallery and it was precisely there that Alfred Stieglitz photographed it, exactly in the position in which Duchamp would have liked to display it, that is, horizontally. The photograph was published in a magazine titled *The Blind Man*, to which Duchamp also contributed.

Ever since, Duchamp's urinal has been one of the best-known icons of contemporary art, featured in nearly every volume on twentieth-century art, and reproduced over and over in almost every form. Quite popular as covers of aesthetics books, ready-mades have been a source of inspiration for artists, who introduced their own variations, as also happened with some painting masterpieces. Sherrie Levine exhibited a replica of Duchamp's *Fountain* in bronze, shiny and glittering as if it were a precious object; Marcel Broodthaers reproduced it branded with the image of the Départment des Aigles in the Service Publicité of his museum of Modern Art; the Georgian artist Avdei Ter-Oganyan smashed one into pieces and put it back together (*Some Questions of Contemporary Art Restoration*, 1993); another filled one with topsoil and flowers, as if it were a charming flower stand; another (Robert Gober, *Two Urinals*, 1986) instead displayed two, paired and displayed in their upright position, bringing back into the scene the masculine and solitary that

Duchamp wanted to keep at a distance but that, however, he could not eliminate (or didn't want to).

Since then, just about everything has been written about Duchamp's ready-mades. William A. Camfield dedicated an entire book to *Fountain*. Leaving aside the accusations leveled by those conformists who considered them meaningless operations, outrages to art, or obscenities, some placed their value in their constitutive provocation of the original character of art, its uniqueness and beauty. It has been said that they delivered a deadly blow to art's "aestheticity," to all that aims to wheedle and satisfy the senses (in accordance with what Duchamp himself stated in an interview: "to completely eliminate the existence of taste"). Despite this, some considered ready-mades to be abstract sculptures. It might still happen that an unprepared (yet unprejudiced) spectator would react in this way, at least to the most famous ready-mades, like the bottle rack or the urinal.

It has been claimed that they intentionally annihilate the very meaning of the object (the more we look at them, the less we know what they are), and their power of alienation has been exalted ("the chosen object is simply isolated, qualified, eradicated from its environment, projected in a new world," as Michael Leiris wrote). Ready-mades have been considered intermediate objects lying between ordinary objects and works of art, as works in a somewhat magical and esoteric realm between the sign and the thing. They have been read as paradoxical affirmations of the demiurgic character of the artistic operation, and at the same time as a criticism of the latter, and as a deliberate provocation against the "system of art." Ready-mades have been conceived as the apex of the aniconic line of contemporary art, yet simultaneously others read in them a rehabilitation of realism and of "low" mimetical forms, of the vulgar bodily over the

spiritual (Duchamp must have agreed, as he, beyond adding a mustache and goatee, added the acronym LHOOC [*She has a hot arse*]). They have been read as a radical critique of industrial society, because of their wrong employment of something that has a precise use, and they have also been considered as perfectly functional to a society of mass production. An art that deconstructs the very basis of immediate sensible perception is another way they have been described, or an art reduced to the pure minimal statement "this is art." Ready-mades have been conceived as a reflection on the relationship between art and names (Filiberto Menna, an Italian critic, writes that "the thing gets its root in the dominion of tautology, celebrating, by resembling itself, the fundamental law of identity"). Starting in the 1960s, Duchamp attracted extraordinary critical attention, exercising simultaneously an enormous influence on artistic movements, so much so that Octavio Paz characterized him as the most influential artist of the century together with Picasso (though, obviously, in a completely different way). When Andy Warhol exhibited his *Brillo Boxes* in a New York gallery, boxes of soap pads like those available on the supermarket shelves, his gesture presupposes Duchamp's, even though it is neither materially analogous (Warhol's are plywood reproductions rather than real boxes) nor conceptually identical (Warhol's object was an industrial mass product, which was what motivated the choice in the first place). Through a *pop* reformulation, ready-made becomes the bench test of aesthetic theory. It is because of *Brillo Boxes* that the philosopher and art critic Arthur Danto formulated the key problem that all of his subsequent reflections tried to solve. If there is no *perceptible* difference between the boxes sold in the supermarket and those exhibited in a gallery, if the two are perceptually identical, why is the industrial product not art, while Warhol's rendering is? If Duchamp's *Fountain* has

nothing that makes it different from the same object found in a store, why is it considered a work of art? Danto's first answer— in "The Artworld"[1]—is that the store is not an art gallery, and that we cannot consider the *Brillo Boxes* independently from the gallery in which they are exhibited. In his systematic book on aesthetics, *The Transfiguration of the Commonplace*, published in 1981, Danto would say that the difference would not be an *ostensible* one, but rather lie in a *theory of art*. Art becomes inseparable from its philosophy. But already in his essay from 1964, in order to avoid his thesis being reduced to a sociological consideration, he specified that "what in the end makes the difference between a Brillo box and a work of art consisting of a Brillo box is a certain theory of art. It is the theory that takes it up into the world of art, and keeps it from collapsing into the real object which it is."[2]

George Dickie stressed instead the sociological-conventional aspect of the matter in his *Art and the Aesthetic: An Institutional Analysis*. For Dickie as well, evidently, the ready-made is the theory of art's test case par excellence. It is precisely by considering Duchamp's operation that Dickie finds the key factor that makes a work of art be the *conferring of the status of the work of art*. "When the objects are bizarre, as those of the Dadaists are, our attention is forced away from the object's obvious properties to a consideration of the objects in their social context. As works of art Duchamp's 'readymades' may not be worth much, but as examples of art they are very valuable for art theory."[3] A long and complex debate was sparked by Dickie's institutional theory, a debate still raging (though somewhat limited to North American aesthetic circles) that is haunted by Duchamp's ghost, even though a distinction has been drawn between *weak* and *strong institutionalism*, with Duchamp's name associated with the latter only.[4]

I won't be delving into that discussion here, as that would require a lengthy consideration of the contemporary analytic aesthetic. (Duchamp's ready-mades remain paradigmatic also for the subsequent definitions of art advanced by analytic aesthetics, for example, the so-called historical characterization advanced by Jerrold Levinson or the narrative one of Nöel Carroll.) The general definition of art at issue in these debates falls, in fact, outside the scope of this work. But, above all, I won't be tracking such discussions because what interests me is putting into focus an element that represents their very indispensable premise. If in fact there is no aspectual, perceptible difference between the real object and the object presented as a work of art, then the artistic character of a work of art has been completely concealed. The maker of ready-mades acts as the most traditional of artists: she hides and conceals her art. She conceals it so well that it becomes completely invisible, absolutely concealed.

This conclusion seems to be backed up by the inescapable force of syllogism. Things *ought to be* like this: if it is art, but we can't see it, art *should* be a concealed art. And yet, once this conclusion is reached (or, better, deduced), we can't deny the uncomfortable truth it carries, making it look quite unsuitable. Something seems not quite right. The traditional use of *ars est celare artem* expressed the idea that one should conceal art as an ability, a mastery, and an excellence. The great artist was such because she was able to use a supreme skill and dissimulate it at the same time, so that it could perform at a subtler level without being in the way of the spectator or the consumer. In the case of the ready-made, this crafty, artisan dimension of art is instead completely lost. If concealing art means hiding a skill, in the case at hand there simply is no skill to hide. This is suggested by the very name coined by Duchamp: *ready-made* means already

made, ready to use. The artist did not intervene in the materiality of the object at all, and it did not undergo any metamorphosis. She didn't rework the materials, or transform them. The artisan and technical dimension of art is completely nonexistent. This art is not "made according to art." And this is confirmed by its complete reproducibility. We know that the objects originally chosen by Duchamp were lost and replaced by replicas. We know that Duchamp authorized the circulation of replicas and duplicates of his ready-mades. In 1964, Galleria Schwarz of Milan circulated thirteen ready-mades in an edition of eight signed copies. And we are aware that Duchamp's ready-mades can be *described* without compromising their effect.

But if it is impossible that art so concealed amounts to art as skill and mastery—which is in fact programmatically excluded by ready-mades understood as a protest against the artisan dimension of art in the form of "retina" art—then what does the art so concealed amount to? What kind of art remains concealed? The answer might be stated this way: the art that remained concealed is all that is implied in art. What is concealed is the very face of art, that is, art as activity, form, and difference from the ordinary object. By proclaiming its identity with the ordinary object, this art conceals its nature as art, and yet, in so doing, it reveals itself, as it becomes a statement about art, while ordinary objects do not state anything but rather are simply what they are. Ready-made thus has an essentially parasitic character, as it lives at the expense of traditional art. The following claim illustrates this point: in a world without traditional works of art, and in which the only works of art were ready-mades, nobody would perceive them as art. By negating itself as art, the ready-made becomes it, in the very act of this negation. The paradoxical character of art resembles the metalinguistic capacity of language: as the latter is able to absorb everything

because of its capacity to speak about itself, so art is able to retrieve any procedure as art because, as Danto happened to claim, "anything can be art without having to look like art at all."[5]

So, in the end, antiart is a form of art. To annihilate art with art, following Tristan Tzara's plan, means to keep it alive. The antiartist, from Duchamp to Manzoni and Cattelan, is still an artist, willing or not. We knew this already, as we acknowledged that *to mock art* can be a way of performing art: "*beffare l'arte con l'arte istessa*" ("to fool art by means of art itself"), as Guazzo used to say, or "*se jouer de l'art*" ("jeer at art"), as Montesquieu said. Contemporary art institutionalized the fooling of art, and antiartistry is one of the most recent features of art:

> Attacking art with artworks is an artistic activity that provides audiences with an aesthetic experience. With some relief, they learn to welcome the attack itself as art. It is the breadth of this aesthetic embrace, its near-inescapability, that makes the interrogative art project such a heroic one. The project subverts the distinction between art and non-art, and proposes a fresh category, anti-art, one comprising many unpredictable instances, including ironic prescriptions for art itself. Ad Reinhardt's 1957 art-cancelling art manifesto, *Twelve Rules for a New Academy*, is exemplary of this project. It commands: no texture, no forms, no colors, no space, no time, no object, no subject. . . . So the rules continue, chocking off the possibility of art in their prescriptions of art.[6]

Compare this with John Cage's "no subject, no image, no beauty, no talent, no technique, no idea, no intention, no art, no feeling."

Art without art is one of the key phrases of twentieth-century art, and it is no wonder that it has been coined by authors engaged in writing its history. Werner Hofmann titled one chapter

of his book "Die Grundlagen der modernen Kunst" ("The Art of the Absence of Art").[7] But an art without art, we know only too well, cannot be but an art that concealed its artistry features. This is exactly what happens in many cases, and sometimes quite explicitly. Think about all *randomized* processes in contemporary art, that is, all those processes that replace (either completely or partially) the artist's pondered choice with *casuality*. As a compositional principle, chance can be found in a number of artistic movements spanning from music (Cage, Boulez, Stockhausen) to painting (Hans Harp's *According to the Law of Chance*, action painting's *drippings*, the informal). But to vindicate the right of chance means resolutely remaining distant from the *projected* character of the works of art, that is, from art as a technique. And in order to grasp how this total renunciation of the artisan dimension of art can still amount to art, we need to remember the teachings of *iki*, that in art *to have it might mean not having it*. John Cage never tried to hide his debt to Zen, and one of his most-known aphorisms reads: "having no goals is the highest goal."

Even that part of the public most suspicious of modern art catches a glimpse of this art without art when it makes the divinatory claim "even a child could have done it" (or its variation, "I can do that"). What is missing, instead, is the fact that art's deprivation of its marks of artistry, the renunciation of parading one's talents, is but the endpoint of a process hundreds of years long, a process that we might label as the *loss of the brand of artistry*. The verbal arts took this path long ago. What are, in fact, the Romantic polemics against poetic diction if not the acknowledgment that the whole codified repertoire of poetry—all the "ordinary artifices to elevate style and raise it above prose," all the personifications of abstract ideas, the exhibited rhetorical figures, and so on—*does not get us closer to but rather*

further from true poetry? How important has it been for twenti-eth-century Italian poetry to free itself from a fixed and alleg-edly *poetical* literary language, and to strive to find a new poetical language far from the language of tradition?

For quite a long time, theater spoke in verses, and only in the last couple of centuries did it become natural to speak naturally, that is, in prose. The vicissitudes of novels are even more telling: this genre, considered for a long time as only para- and under-literary, a spurious genre resistant to any codification, more and more relying on prose, that is, on a language lacking the formal features of artistry, in the seventeenth century started a progres-sive shift from the periphery to the center of artistic production, and now it occupies almost the entire scene. The visual arts didn't stop short of this process either, in fact pushing it to its extremes, refuting the genres and forms offered by the tradition and aiming with more and more insistence at the ordinary, the common, the everyday, and even the filthy, the disgusting, the outrageous. There is no material, no matter how poor or repulsive, that is debarred from being employed in art, and in the same way there is no subject or "aura" surrounding the object and conferring the title of art. If anything, it is bad or kitsch art that continued to believe in the existence of something constitutively or intrin-sically "poetic."

But if the spreading of an art that questions the traditional marks of artistry, which disavows the form and seeks a para-doxical *form without form*, is a fundamentally modern event, the polarity between the *technical* and the *creative* aspect is probably older, and perhaps *constitutive* of it. There is in art a component ascribable to some kind of know-how, that is, to a regulated skill. This component makes art a craft, and thus also the exhibition of the skills involved in it. Isn't the *masterpiece*, from an etymo-logical point of view, the *first piece* with which the apprentice

shows herself to have perfectly mastered the rules imparted to her?[8] Yet, art is at the same time the capacity to go beyond rules in unpredictable ways, to play with the rule as well as within the rules; it is an invention impossible to foretell and incapable of indicating its own development. Because of this second aspect, art eludes all the attempts to reduce it to a procedure, since the absence of a procedure can amount to a procedure as well.[9]

In the history of aesthetics, this duplicity has been glimpsed and thematized: Schelling, for example, used to say that art is the result of two rather similar activities, the union of a conscious with an unconscious aspect, calling the former *art* and the latter *poetry*:

> If we are to seek in one of the two activities, namely the conscious, for what is ordinarily called *art*, though it is only one part thereof, namely that aspect of it which is exercised with consciousness, thought and reflection, and can be taught and learnt and achieved through tradition and practice, we shall have, on the other hand, to seek in the unconscious factor which enters into art for that about it which cannot be learned, nor attained by practice, nor in any other way, but can only be inborn through the free bounty of nature; and this is what we may call, in a word, the element of *poetry* in art.[10]

Schelling did not privilege poetry over art, as we might expect from a Romantic thinker; he claimed instead that neither of the two elements, taken in isolation, has any value. Only when joined together do the two give rise to the true work of art, and genius doesn't lie in one or the other but rather consists in the capacity to stand above both and unify them. Also, he arrived at the claim that we should expect far more "that art without poetry should be able to achieve something, than poetry without art."

In a similar way, Kant said that among the two faculties nec-
essary for the work of art, taste and genius, if one is forced to
give way, we should opt for the latter rather than the former. He
writes:

> Although mechanical and beautiful art, the first as a mere art
> of diligence and learning, the second as that of genius, are very
> different from each other, still there is no beautiful art in which
> something mechanical, which can be grasped and followed ac-
> cording to rules, and thus something *academically correct*, does
> not constitute the essential condition of the art. For something
> in it must be thought of as an end, otherwise one cannot ascribe its
> product to any art at all; it would be a mere product of chance. But
> in order to aim at an end in the work, determinate rules are re-
> quired, from which one may not absolve oneself. Now since the
> originality of his talent constitutes one (but not the only) essen-
> tial element of the character of the genius, superficial minds be-
> lieve that they cannot show that they are blossoming geniuses
> any better than by pronouncing themselves free of the academic
> constraint of all rules, and they believe that one parades around
> better on a horse with the staggers than one that is properly
> trained.[11]

This, however, does not undermine that, according to Kant,
if art is beautiful when it has the appearance of nature, then
the obedience to rules should appear spontaneous and not
contrived:

> Thus the purposiveness in the product of beautiful art, although
> it is certainly intentional, must nevertheless not seem inten-
> tional; i.e., beautiful art must be *regarded* as nature, although of
> course one is aware of it as art.[12]

An absolute creativity, completely disjoined from rules, appeared to Kant as pernicious for art as the mechanical conformity respectful of rules. Perhaps we could add that the very concept of an *absolutely free* creativity is hardly thinkable. An *absolute* creativity adjoins the pure will, pure nonsense, the solipsistic delirium. As is well known, bonds, in art, rather than being necessarily a dead weight, can create the condition for invention, and even stimuli for it.[13] Even the ready-made, which seemed to be unconstrained (any object can be art, even without undergoing any transformation), could not be constituted without a reference to a presupposed art tradition. Ready-mades, apparently free from any norm, are in truth possible only as a parasite of a given norm.

On the other hand, however, in art no rule can guarantee success. The most accredited procedure, the most accurate way to impress, the employment of the most complex techniques still say nothing about the achievement of the goal. Every time a formula of artistry has been sought, every time its clues have been listed, failure has been the result. The symptoms of the aesthetic advanced by Goodman or the requirement of the poetic function suggested by Jakobson are always falsifiable, because one can always find a work in which such symptoms or requirements are not present but yet is a work of art, and, vice versa, there are works showing those features that are not works of art.[14] And it is *inevitable* that that is the case if it is true that, as Longinus knew only too well, *the absence of a figure can amount to a rhetorical figure*, the lack of ornament can represent an ornament, and the absence of art might be a way of doing art.

If so, if art seems to be in need of rules and at the same time needs to be able to do without them, we are then able to understand why *ars est celare artem* is a maxim vindicated in the most diverse situations. It was not only a rhetorical trick, an artistic

ideal of naturalness, the key word for the desire that classic art has for purity and simplicity. It was also the way, paradoxical as it might sound, to hold together freedom and constraint in art, invention and craft, creativity and technique. The best way to express it, more effectively than many lengthy discussions, is that art is always describable and yet defies description, always susceptible to interpretation and yet refutes it, always explicit and yet enigmatic, transparent as a crystal and yet mysterious as a hieroglyphic.

NOTES

1. CONCEALMENT

1. R. La Capria, *Letteratura e salti mortali* (Milan: Mondadori, 1990), 13.
2. S. Romano, "Il Signor Italia e l'arte nascosta," *Corriere della Sera*, January 24, 2004.
3. A. Gonzáles-Palacios, *Le tre età* (Milan: Longanesi, 1999), 331–32.
4. M. J. Parsons and H. G. Blocker, *Aesthetics and Education* (Chicago: University of Illinois Press, 1993).
5. S. Bettinelli, *Lettere Virgiliane. Lettere inglesi*, ed. E. Bonora (Turin: Einaudi, 1977), 37.
6. G. Leopardi, *Zibaldone*, ed. M. Caesar and F. D'Intino (New York: Farrar, Straus and Giroux, 2013), no. 10; N. Tommaseo, *Dizionario della lingua italiana*, s.v.; S. Battaglia, *Grande dizionario della lingua italiana*, s.v.; C. Campo, "Con lievi mani," in *Gli imperdonabili* (Milan: Adelphi, 1987), 98.
7. B. Castiglione, *The Book of the Courtier*, trans. L. E. Opdycke (New York: Scribner's, 1903), bk. 1, 35.
8. Ibid., bk. 1, 33.
9. Ibid., bk. 1, 35.
10. Catullus, *Carmen 86*, in *Carmina*, in *The Complete Poems*, trans. G. Lee (Oxford: Oxford University Press, 2008), p. 131.
11. Pliny the Elder, *Natural History*, trans. H. Rackham, Loeb Classical Library 330 (Cambridge: Harvard University Press, 1952), vol. 9, bk. 35, p. 319.

12. About the connection between grace, a certain something, and art concealing, see P. D'Angelo and S. Velotti, *Il "non so che": Storia di un'idea estetica* (Palermo: Aesthetica, 1997), in particular pp. 23–24; and R. Scholar, *The Je Ne Sais Quoi in Early Modern Europe: Encounters with a Certain Something* (Oxford: Oxford University Press, 2005).

13. About the history of the concept of "grace," in addition to the classic paper by S. H. Monk, "A Grace Beyond the Reach of Art," *Journal of the History of Ideas* 5 (1944): 131–50, see M. Rossi Monti, *Il cielo in terra: La grazia tra teologia ed estetica* (Turin: UTET, 2008); and R. Milani, *I volti della grazia* (Bologna: Il Mulino, 2010).

14. See, in particular, P. Burke, *The Fortunes of the Courtier: The European Reception of Castiglione's Cortegiano* (Cambridge: Polity, 1995).

15. Baldassarre Castiglione, Carmen Covito, and Aldo Busi, *C. Covito and A. Busi traducono il Cortegiano* (Milan: Rizzoli, 1993), 72.

16. R. Klesczewski, *Die französischen Uebersetzungen des Cortegiano* (Heidelberg: Winter, 1966).

17. For the Spanish translations, see M. Morreale, *Castiglione y Boscán: El ideal cortesano en el Renascimento español* (Madrid: Fundation Conde de Cartagena, 1959), 163–65.

18. C. Nocera Avile, *Tradurre il Cortegiano: The Courtier of Sir Thomas Hoby* (Bari: Adriatica, 1992), 74–75. On the translation of the term *sprezzatura*, see Burke, *The Fortunes of the Courtier*, 65–66.

19. See the many studies about the opposition between *sprezzatura* and *affectation*: R. Mercuri, "Sprezzatura e affettazione nel *Cortegiano*," in *Letteratura e critica: Studi in onore di Natalino Sapegno*, ed. W. Binni, vol. 2 (Rome: Bulzoni, 1975); E. Saccone, "'Grazia,' 'sprezzatura' and 'affettazione' in Castiglione's *Book of the Courtier*," *Glyph* 5 (1979), now in Saccone, *Le buone e le cattive maniere: Letteratura e galateo nel Cinquecento* (Bologna: Il Mulino, 1992), 35–56; G. Ferroni, "Sprezzatura e simulazione," in *La Corte e il "Cortegiano,"* ed. C. Ossola (Rome: Bulzoni, 1980), 1:119–48; H. Berger, *The Absence of Grace: Sprezzatura and Suspicion in Two Renaissance Courtesy Books* (Stanford: Stanford University Press, 2001); T. Ricci, "La grazia in Baldassar Castiglione: Un'arte senz'arte," *Italianistica* 32, no. 2 (2003), 235–45.

20. See C. Ossola, *Dal Cortegiano all'uomo di mondo: Storia di un libro e di un modello sociale* (Turin: Einaudi,1987), 55.

21. J. Nevinson, *Raffella of Master Alexander Piccolomini: Or Rather, A Dialogue of the Fair Perfectioning of Ladies: A Werke Very Necessarie and Profitable for All Gentlewomen or Other; Written First in the Italian Tongue for the Academy of the Thunderstricken in Siena and Now First Done Into English* (Glasgow: University of Glasgow Press, 1968), italics mine.

22. S. Guazzo, *The Art of Conversation: In Three Parts* (London, 1738), 15 (available at the website of the British Library).

23. L. B. Alberti, *Iciarchia*, in *Opere volgari* (Firenze, 1845), 3:72–73. E. Bonora quotes this passage as an antecedent of the concept of *sprez-zatura* in Bonora, "Il classicismo dal Bembo al Guarini," in *Storia della letteratura italiana* (Milan: Garzanti, 1960), 4:204.

24. Castiglione, *The Book of the Courtier*, bk. 1, 36–37.

2. PART OF ELOQUENCE IS TO HIDE ELOQUENCE

1. A. Quondam, introduction to *The Book of the Courtier: The Singleton Translation* (New York: Norton, 2002); R. A. Lanham, *The Motives of Eloquence: Literary Rhetoric in the Renaissance* (New Haven: Yale University Press, 1976), 144; see also M. Fumaroli, *L'âge de l'éloquence: Rhéthorique et "res literaria" de la Renaissance au seuil de l'époque classique* (Geneva: Droz, 1980), in which Castiglione's "Ciceronianism" is largely emphasized. On the rhetoric model of courtesan training books, see also M. Hinz, *Rhetorische Strategien des Hofmannes* (Stuttgart: Metzler, 1992).

2. L. Vilmaggi pointed this out for first in "Per le fonti del Cortegiano," *Giornale storico della letteratura italiana* 14 (1889): 72–93.

3. Cicero, *De oratore*, trans. E. W. Sutton (Cambridge: Harvard University Press, 1967), 2.1.4.

4. Quintilian, *Institutes of Oratory*, ed. Lee Honeycutt, trans. John Selby Watson, http://rhetoric.eserver.org/quintilian/, 199–200.

5. Plato, *Apology of Socrates*, 17c: "from me you will hear the whole truth—but by Zeus, men of Athens, not beautifully spoken speeches like theirs, adorned with phrases and words; rather, what you hear will be spoken at random in the words that I happen upon—for I trust that the things I say are just—and let none of you expect otherwise."

Plato's Apology of Socrates: An Interpretation with a New Translation, trans. T. G. West (Cornell: Cornell University Press, 1979).

6. F. Dostoevsky, *Brothers Karamazov*, trans. Andrew R. MacAndrew (1970; New York: Bantam Dell, 2003), 2076–77, 2081, 2088, 2118.

7. Quintilian, *Institutes of Oratory*, 2.10.11.

8. Ibid., 4.1.56–57.

9. F. Philostratus, *The Life of Apollonious*, trans. F. C. Conybeare, Loeb Classical Library, (London: Heinemann; Cambridge: Harvard University Press, 1948), 8, chap. 6.

10. Quintilian, *Institutes of Oratory*, 4.1.8.

11. See G. Neumeister, *Grundsätze der forensichen Rethorik* (Munich: Hübner, 1964), chap., "Das Verbergen der rethorischen Kunst," 130–55, which we are following here. Quite insufficient instead is the entry *Dissimulatio* by F. Népote-Desmanes and T. Tröger in G. Ueding, ed., *Historiches Wörterbuch der Rethorik*, vol. 2 (Tübingen: Niemeyer, 1994).

12. Quintilian, *Institutes of Oratory*, 4.1.8, 4.5.4.

13. Cicero, *Rhetorica ad Herennium*, trans. Harry Caplan (Cambridge: Harvard University Press, 1954), 31.

14. Cicero, *De oratore*.

15. Quintilian, *Institutes of Oratory*, 4.2.126–27.

16. Ibid., 4.2.58.

17. Ibid., 1.11.3.

18. Ibid., 9.4.143–44.

19. Dionysius of Halicarnassus, *Lysias*, in *Critical Essays*, vol. 1, trans. Stephen Usher, Loeb Classical Library (Cambridge: Harvard University Press, 1974).

20. Quintilian, *Institutes of Oratory*, bk. 8, introduction, 18.

21. W. Shakespeare, *Hamlet*, act 5, scene 1.

22. Quintilian, *Institutes of Oratory*, 11.1.49–50 and 9.3.102.

23. Aristotle, *Rhetoric*, trans. W. Rhys Roberts (London: Oxford University Press, 1910–31), vol. 9, 1404b, 18–23.

24. Ibid., 1406a 12–14, 1408b 6–10. On these passages, see the Renaissance comment on *Rhetoric* by Pier Vettori: "Operam dare debemus, ut cum hoc attingimus, clam id faciamus, nec artificium nostrum intelligatur ab iis, apud quos dicimus: sed ut natura duce, hoc facere videamur: si hoc numquam obtinemus, fidem facile facemus." Pier

Vettori, *Commentarii in tres libros Aristotelis de arte dicendi* (Florence: In officina Bernardi Iunctae, 1568), 462.

25. Aristotle, *Nicomachean Ethics*, 1127a 33–1128b 9; see also Aristotle, *Rhetoric*, 1410b 6.

26. S. Guazzo, *The Art of Conversation (La Civil Conversazione)*, trans. G. Pettie and B. Young (London, 1581–86), 105–6.

27. D. Barbaro, *Della Eloquenza*, in *Trattati di poetica e retorica del Cinquecento*, ed. B. Weinberg (Bari: Laterza, 1970), 2:337 and 447.

28. Ch. Rollin, *Della maniera di insegnare e di studiare le belle lettere* (Naples: Di Bisogno, 1796), 2:252–53; A. E. Chaignet, *La rhétorique et son histoire* (Paris: Bouillon, 1888), 455.

29. O. Reboul, *La retorica* (Milan: Il Castoro, 2004), 5e93.

30. Seneca the Elder, *Controversiae*, 10, preface.

31. Euripedes, *Phoenissae*, in *The Plays of Euripides*, trans. E. P. Coleridge (London: G. Bell, 1910), 1:469–72.

32. Goethe, *Urfaust, Night*, in *Faust: A Tragedy in Two Parts and The Urfaust*, trans. John R. Williams (Ware: Wordsworth, 1999), p. 388, verses 194–204.

3. THE CONCEALED ORNAMENT

1. Cicero, *Orator*, trans. C. D. Yonge (Hastings: Delphi, 2014), 23. M. Fumaroli, *L'âge de l'éloquence: Rhéthorique et "res literaria" de la Renaissance au seuil de l'époque classique* (Geneva: Droz, 1980) reads Castiglione's *sprezzatura* as a translation of Cicero's *neglegentia diligens*.

2. Plato, *Gorgias*, trans. W. Hamilton and C. Emlyn-Jones, rev. ed. (New York: Penguin, 2004), 465b.

3. Quintilian, *Institutes of Oratory*, ed. Lee Honeycutt, trans. John Selby Watson, http://rhetoric.eserver.org/quintilian/bk. 8, introduction, p. 19.

4. Ibid., 8.3.87.

5. Ovid, *Ars Amatoria*, 3.153–54: "Take the 'careless look,' which suits a lot of girls: / To judge by their wild curls / You'd think they'd been slept on all night, but they've just / This moment been carefully mussed! / Art simulates chance effects" (*The Art of Love*, trans. James Michie [London: Penguin, 2002]).

6. Ibid., 3.210.

7. B. Castiglione, *The Book of the Courtier*, trans. L. E. Opdycke (New York: Scribner's, 1903), 1.40.

8. S. Guazzo, *The Art of Conversation: In Three Parts* (London, 1738), 197–98 (available at the website of the British Library).

9. "You do not quite know whether to say she adorns or neglects herself, whether accident or art composed her lovely face. Her negligencies are the artifices of Nature, of Love, of her friendly stars." T. Tasso, *Jerusalem Delivered*, trans. Ralph Nash (Detroit: Wayne State University, 1987), 2.18.

10. B. Jonson's poem, "Still to Be Neat, Still to Be Dressd," has been compared to Tasso's quoted lines in M. Praz, "Armida's Garden," *Comparative Literature Studies* 5, no. 1 (March 1968): 16–17.

11. In relation to these aspects, see D'Angelo, *Estetismo* (Bologna: Il Mulino, 2003), chap. 4. Said Captain Jesse about Lord Brummel: "His chief aim was to avoid anything marked,. . . one of his aphorisms being that the severest mortification a gentleman could incur was to attract observation in the street by his outward appearance."

12. Quoted in G. Scaraffia, *Gli ultimi dandies* (Palermo: Sellerio, 2002), 157. As Scaraffia points out: "The self-concealing of the dandy masterly resembles the greatest ease of carelessness."

13. C. Baudelaire, "In Praise of Make-Up," in *The Painter of Modern Life*, trans P. E. Charvet (London: Penguin, 2010), 82–83.

14. Castiglione, *The Book of the Courtier*, 1.40.

15. Giangiorgio Trissino, in the first book of his *Poetica* (1529), distinguishes three kinds of rhetorical artifices: an artifice that is and appears (that is, the ordinary artifice, as we may put it), that which is but does not appear (that is, the artifice that conceals itself beyond simplicity), and that which is not and does not appear, which is the affected, useless, and empty one.

16. Groupe μ, *A General Rhetoric*, trans. Paul B. Burrell and Edgar M. Slotkin (Baltimore: Johns Hopkins University Press, 1981). On these themes, see M. Ferraris, "Metafora, proprio, figurato: Da Loos a Derrida," *Rivista di Estetica* 12 (1982): 60–74.

17. C. Benedetti (following J. M. Lotman's suggestions) speaks about the relation between conventionality and the need for its rejection as constitutive of the evolution of art in Benedetti, "Il sublime e la non-arte," *Rivista di Estetica* 30, no. 36 (1990): 55–64. See also C. Benedetti,

L'ombra lunga dell'autore (Milan: Feltrinelli, 1999), in particular chaps. 5 and 6.

18. Obviously, any discussion about the dating of the *Sublime* falls outside our present scope. See the accurate *presentazione* by G. Lombardo in Pseudo-Longino, *Il Sublime* (Palermo: Aesthetica, 1992), the first edition of which was published in 1987. It may be of interest to remind that some relation between Quintilian and Pseudo-Longinus has been hypothesized in I. Lana, "Quintiliano, il Sublime e gli esercizi preparatori di Elio Teone," *Pubblicazione della Facoltà di Lettere e Filosofia* 3, no. 4 (1951).

19. Pseudo-Longinus, *On the Sublime*, trans. W. Hamilton Fyfe, rev. Donald Russell (Cambridge: Harvard University Press, 1995), bk. 17, p. 231.

20. In saying this, we are not endorsing the "actualizing readings" of Longinus, which have been proposed in some Italian works: see, for example, A. Rostagni, "Il 'Sublime' nella storia dell'estetica antica," in *Scritti minori: Aesthetica* (Turin: Bottega d'Erasmo, 1955); or G. Martano, introduction to Pseudo-Longino, *Del Sublime* (Bari: Laterza, 1965). But we are noticing the emergence of what today can be recognized as an authentic *aesthetic* problem, independent from the rhetorical problem of identifying the characteristics of the *genus sublime*.

21. Pseudo-Longinus, *On the Sublime*, chaps. 9 and 31.

22. Ibid., chap. 17.

23. Ibid. chap. 3.

24. Ibid., chaps. 24 and 32.

25. Demetrius, *On Style*, trans. Doreen C. Innes, Loeb Classical Library (Cambridge: Harvard University Press, 1995), 186: "Just as the frigid style was adjacent to the grand style, so there is a faulty style next to the elegant style, and I call it by that broad term, the affected style."

26. Ibid., 67. See also the comment in Lombardo in Pseudo-Longino, *Il Sublime*, 122, in which he recalls a particularly pertinent passage from G. Leopardi, *Zibaldone*, ed. M. Caesar and F. D'Intino (New York: Farrar, Straus and Giroux, 2013), nos. 4216–17.

27. Also on this point, see Lombardo's comment, in Pseudo Longino, *Il Sublime*, 201–8.

28. Pseudo-Longinus, *On the Sublime*, chap. 22.

29. Castiglione, *The Book of the Courtier*, 1.34.

30. I. Kant, *Critique of Judgment*, trans. P. Guyer and E. Matthews (Cambridge: Cambridge University Press, 2002), section 45 (the paragraph is titled "Beautiful art is an art to the extent that it seems at the same time to be nature"). That art is perfect when it seems to be nature is a widespread belief, and, for example, we find it in Diderot: "It appears that we consider nature to be a result of art and in return if the painter can repeat the same spell onto the canvas, it appears that we are looking at the effect of art as though it were that of nature." Diderot, "The Countryside," in *On Art and Artists: An Anthology of Diderot's Aesthetic Thought*, ed. J. Seznec (Dordrecht: Springer, 2011), 87.

31. A. O. Lovejoy, "Nature as Aesthetic Norm," *Modern Language Notes* 42 (1927).

32. Castiglione, *The Book of the Courtier*, 2.12.

33. H. v. Kleist, "On the Marionette Theatre," trans. Idris Parry, www .southerncrossreview.org/9/kleist.htm.

34. See S. Velotti, *Storia filosofica dell'ignoranza* (Rome: Laterza, 2003), in particular 45–50. For the discussion of "States that are essentially by-products," see J. Elster, *Sour Grapes* (Cambridge: Cambridge University Press, 1983), chap. 2; see also Ch. Perelman and Olbrechts-Tyteca, *The New Rhetoric* (Notre Dame: Notre Dame University Press, 1969), 450.

35. Ovid, *Metamorphoses*, trans. St. Lombardo (Indianapolis, Hackett, 2010), 10.240–97. About the theme of *artem celare* in Ovid, see L. Spahlinger, *Ars latet arte sua: Untersuchungen zur Poetologie in den Metamorphosen Ovids* (Stuttgart: Teubner, 1996), 50–63.

4. ART OR NATURE?

1. B. Castiglione, *The Book of the Courtier*, trans. L. E. Opdycke (New York: Scribner's, 1903), 1.27.

2. Pliny the Elder, *Natural History*, trans. H. Rackham, Loeb Classical Library 330 (Cambridge: Harvard University Press, 1952), vol. 9, bk. 35, 36.

3. Cicero, *The Orator*, trans. C. D. Yonge (Hastings: Delphi, 2014), chap. 21, p. 73.

4. Leon Battista Alberti, *On Painting*, trans. John R. Spencer (New Haven: Yale University Press, 1970), bk. 3, pp. 61–62.

5. L. Ghiberti, *I Commentarii* (Florence: Giunti, 1998), 72–73, my translation.

6. On the significance of this edition for the history of the *Courtier* reception, see C. Ossola, "Il libro del Cortegiano: Esemplarità e difformità," in *La Corte e il "Cortegiano*," ed. C. Ossola (Rome: Bulzoni, 1980), 43–47.

7. L. Dolce, *Aretin, a Dialogue on Painting: From the Italian of Lodovico Dolce*, trans. W. Brown (London: P. Elmsley, 1770), 13.

8. Ibid., 160–61, italics mine.

9. Francisco de Hollanda, *Dialoghi Romani* (1548; Milan: Rizzoli, 1964), 80–81.

10. G. B. Gelli, *Ragionamento sulla lingua* in *Dialoghi* (1551; Bari: Laterza, 1967), 308–9. On the theme of *ars celare* in Michelangelo, see R. J. Clements, *Michelangelo's Theory of Art* (New York: New York University Press, 1961). Clements indicates Savonarola's sermon from 1496 as one of Michelangelo's sources.

11. This is the case, in part at least, of A. Blunt, *Artistic Theory in Italy* (Oxford: Oxford University Press, 1962), in particular 93–98. See also R. Wittkower, "Genius: Individualism in Art and Artists," in *Dictionary of the History of Ideas*, ed. Ph. P. Weiner, vol. 2 (New York: Scribner's, 1973).

12. G. Vasari, *The Lives of the Artists*, trans. J. Conaway Bondanella and P. Bondanella (Oxford: Oxford University Press, 1998), 278.

13. G. Vasari, *Lives of the Most Eminent Painters, Sculptors and Architects*, trans. Gaston Du C. De Verb and Philip Lee Warner (London: Medici Society, 1915), 10:187. This part is not included in the translation quoted in the previous note.

14. Ibid., 3:127; 2:74; 3:147.

15. G. Comanini, *The Figino, or On the Purpose of Painting*, trans. A. Doyle-Anderson and G. Maiorino (Toronto: University of Toronto Press, 2001), 97.

16. G. P. Lomazzo, *The Idea of Temple of Painting*, ed. and trans. Jean Julia Chai (University Park: Pennsylvania State University Press, 2013), 158.

17. F. Junius, *The Painting of the Ancients* (London: R. Hodkinsonne, 1683), 328.

18. See L. Grassi, "Sprezzatura, Sprezzo," in *Dizionario dei termini artistici*, by L. Grassi and M. Pepe (Milan: TEA, 1994).

19. F. Scannelli, *Microcosmo della pittura*, ed. G. Giubbini (Milan: Labor, 1966), 17, italics mine.

20. G. P. Bellori, *The Lives of Modern Painters, Sculptors and Architects*, ed. H. Wohl and T. Montanari, trans. A. Wohl (Cambridge: Cambridge University Press, 2005), 184.

21. A. C. Count of Caylus, *Sur la légerté de l'outil* (1755), quoted in B. Saint-Girons, *Fiat Lux: Una filosofia del sublime*, trans. C. Calì and R. Messori (Palermo: Aesthetica, 2003), 179–83.

22. R. Mengs, *Works* (London: R. Faulder, 1796), chap. 3, p. 27.

23. G. Spalletti, *Saggio sopra la Bellezza*, ed. P. D'Angelo (Palermo: Aesthetica, 1992), 61–62, italics mine.

24. É. M. Falconet, *Réflexions sur la sculpture*, in *Oeuvres complètes*, vol. 3 (Geneva: Slatkine, 1970); Italian translation in Diderot et al., *L'estetica dell'encyclopédie*, ed. M. Modica (Rome: Editori Riuniti, 1988), 206–7. See also D. Diderot, "Sulla pittura" in Diderot et al., *L'estetica dell'encyclopédie*, 127–30: *Sulla grazia, la naturalezza e la semplicità; sul naïf e sull'affettazione*.

25. F. Milizia, *Dell'arte di vedere nelle belle arti del disegno*, ed. F. Fanizza (1781; Bari: Edizioni B. A. Graphis, 1998), 52.

26. F. Milizia, lettera riportata in L. Cicognara, *Storia della scultura dal suo Risorgimento in Italia fino al secolo di Canova* (Venezia, 1818), 3:242–43.

27. J. A. D. Ingres, *Écrits et propos sur l'art* (Paris: Hermann, 2014), 32; E. Delacroix, *Journal* (Paris: Plon, 1950), vol. 3, January, 4, 1857.

28. Stendhal, *Histoire de la peinture en Italie* (Paris: Gallimard, 1996), chap. 30. In a footnote Stendhal adds, "what betrays a certain helplessness in the artist destroys the grace of its work, and what instead shows negligence motivated by excess of talent augments it. The same neglected profile can be painted by a besmircher or by a Lanfranco: in the great painter it is generosity, is *sprezzatura*, as the Italians say."

29. J. Ruskin, *Modern Painters*, vol. 1 (London: George Allen, 1906), xxiv and 18.

5. IN THE GARDEN

1. On the context surrounding this collection, see G. Venturi, "La cultura del giardino inglese nel Veneto tra '700 e '800," in *Le scene dell'Eden: Teatro, arte, giardini nella letteratura italiana* (Ferrara: Bovolenta, 1979), 132–59.

2. I. Pindemonte, "Dissertazione su i giardini inglesi e sul merito in ciò dell'Italia," in *Le poesie campestri di Ippolito Pindemonte: Con l'aggiunta di una dissertazione su i giardini inglesi e sul merito in ciò dell'Italia* (Benevento: Tipografia Paternò, 1838), 65. For a general overview of the essay, see B. Basile, "Ippolito Pindemonte e i giardini inglesi," *Filologia e critica* 3 (1981): 329–65. Pindemonte's essay has been reprinted in *L'arte dei giardini: Scritti teorici e pratici dal XIV al XIX secolo*, ed. M. Azzi Visentini (Milan: Il Polifilo, 1999), 2:156–77.

3. Pindemonte, "Dissertazione su i giardini inglesi," 80.

4. Tasso, *Jerusalem Delivered*, trans. Edward Fairfax (London, 1749), bks. 16, 9.

5. Ibid., italics mine.

6. W. Shenstone, "Unconnected Thoughts on Gardening," in *The Works in Prose of William Shenstone* (London: R. and J. Dodsley, 1764), 135.

7. Pindemonte, "Dissertazione su i giardini inglesi," 87.

8. M. Praz, "Armida's Garden," *Comparative Literature Studies* 5, no. 1 (March 1968): 1–20, at 14 and 17.

9. See, in particular, G. Venturi, "I giardini e la letteratura: Saggi d'interpretazione e problemi metodologici," in *Le scene dell'Eden*, 98–13; and G. Venturi, "'Picta Pöesis': Ricerche sulla poesia e il giardino dalle origini al Settecento," in *Storia d'Italia Einaudi*, vol. 5, *Il Paesaggio*, ed. C. de Seta (Turin: Einaudi, 1982).

10. Quoted in A. Rinaldi, "La ricerca della 'terza natura': Artificialia e naturalia nel giardino toscano del '500," in *Natura e artificio*, ed. M. Fagiolo (Rome: Officina, 1979).

11. Praz also seems too precipitous in not questioning the derivation of the Tassonian line *"Arte che tutto fa nulla si scopre"* ("Nowhere appeared the art which all this wrought") from Longinus's *On the Sublime*. On this point see the important observations by G. Costa, "Un annoso problema: Tasso e il Sublime," *Rivista di Estetica* 27, nos. 26–27 (1987): 49–63.

12. J. Addison, "Pleasures of Imagination," *Spectator* 411 (June 21, 1712): no. 414, italics mine.

13. A. Pope, *Epistle to Richard Boyle, Earl of Burlington*, in *The Poetical Works*, ed. A. R. Ward (London: MacMillan, 1876), 256–62. On "gardener" Pope, see, in Italian, T. Calvano, *Viaggio nel pittoresco: Il giardino inglese tra arte e natura* (Rome: Donzelli, 1996), 27–31.

14. H. Walpole, *Essay On Modern Gardening* (Canton, PA: Kirgate, 1904), 67, 81, and 93.

15. R. O. Cambridge, *The Work of Richard Owen Cambridge* (London: Luke Hansard, 1803), 477–78, italics mine.

16. See G. Teyssot, "Un'arte così ben dissimulata: Il giardino eclettico e l'imitazione della natura," in *L'architettura dei giardini d'Occidente*, ed. M. Mosser and G. Teyssot (Milan: Electa, 1990), 359.

17. M. G. Lewis, *The Monk* (New York: Modern Library, 2002), 104–5.

18. Quoted in A. Lovejoy, *Essays in the History of Ideas* (Baltimore: John Hopkins University Press, 1948), 116.

19. J. F. de Saint-Lambert, *Les saisons: Poëme* (Amsterdam, 1775), 51.

20. Abbé de Lille, *Les jardins, ou l'art d'embellir les paysages* (London, 1782), canto 3, p. 53.

21. J. Sulzer, *Allgemeine Theorie der schönen Künste* (New York: Olms, Hildesheim, 1970), "Gartenkunst"; F. Schiller, review of *Taschenkalendar auf das Jahr 1795 für Natur- und Gartenfreunde*, in *Nationalausgabe* (Weimar: Böhlaus, 1959), 22:282–92.

22. V. Marulli, *L'arte di ordinare i giardini* (Naples: Stamperia Simoniana, 1804).

23. J. Baltrušaitis, *Aberrations: An Essay on the Legend of Forms* (Boston: MIT Press, 1989), 157.

24. J. Milton, *Paradise Lost*, bk. 4, lines 241–42.

25. Walpole, *Essay on Modern Gardening*, 9 and 55.

26. J. M. Morel, *Théorie des jardins* (Paris: Pissot, 1776), 368–74 (but notice that at page 381 Morel writes: "Les beautés de la Nature n'ont pas besoin, pour nous plaire, de rappeler les talents de l'artiste . . . elles doivent au contraire cacher avec soin l'art qui les a produites").

27. W. Mavor, *A New Descprition of Blenheim* (1789; Oxford: Slatter and Munday, 1806), 88–90.

28. E. Silva, *Dell'arte dei giardini inglesi*, ed. G. Venturi (Milan: Longanesi, 1976).

29. On this point, see M. Venturi Ferriolo, *Giardino e paesaggio dei romantici* (Milan: Guerini, 1998).

30. L. Mabil, *Sopra l'indole dei giardini moderni* (Verona: Mainardi, 1817).

31. Abbé de Lille, *Les jardin*, canto 1, p. 25.

32. V. Fortunati and E. Zago, introduction to *Saggio sul giardino moderno*, by H. Walpole (Florence: Le Lettere, 1991); this is the Italian translation of *Essay on Modern Gardening*, 30.

33. W. Chambers, *A Dissertation, on Oriental Gardening* (London: Griffin, 1772), v and 14–15.

34. J. Reynolds, *Discourses on Art*, ed. E. G. Johnson (Chicago: McClurg, 1891), 312 and 320–21, thirteenth discourse, 1786.

35. On Rousseau's idea of the garden, see F. Testa, "'Tout cela ne peut se faire sans un peu d'illusion': Naturalità e artificialità nell'arte dei giardini della seconda metà del XVIII secolo," in *Il paesaggio dell'estetica: Teorie e percorsi*, ed. T. E. Deutsch et al. (Turin: Trauben, 1997), 353–64.

36. All the quotations are taken from J.-J. Rousseau, *Julie, or, The New Heloise*, trans. P. Stewart and C. Kelly (Hanover, NH: University Press of New England, 1997), 387–97.

37. I. Kant, *The Critique of the Power of Judgment*, trans. Paul Guyer and Eric Matthews (Cambridge: Cambridge University Press, 2000), 186, 181.

38. Testa, "Tout cela ne peut se faire sans un peu d'illusion," 359.

39. Pindemonte, "Dissertazione su i giardini inglesi," 71.

40. Ibid., 74.

41. Schiller, review of *Taschenkalendar auf das Jahr 1795 für Natur- und Gartenfreunde*; on this, see also G. Pinna, "Il giardino impossibile: Sul concetto di natura in alcuni scritti di Schiller," in Deutsch et al., *Il paesaggio dell'estetica*, 341–46.

42. A. W. Schlegel, "Die Kunstlehre," in *Kritische Schriften und Briefe*, ed. E. Lohner (Stuttgart: Kohlhammer, 1963), 2:178–83; A. Schopenhauer, *The World as Will and Representation*, trans. E. F. J. Payne (London: Dover, 1966), bk. 3, §44. But Schopenhauer has a different position in the *Supplements*: "How aesthetic nature is!. . . Every neglected little place at once becomes beautiful. On this rests the principle of English gardens, which is to conceal art as much as possible, so that it may look as if nature had been freely active" (vol. 2, p. 388).

43. G. W. F. Hegel, *Aesthetics: Lectures on Fine Art*, trans. T. M. Knox (Oxford: Clarendon, 1975), 2:699, italics mine.

6. IKI

1. M. Heidegger, "A Dialogue on Language," in *On the Way to Language*, trans. P. D. Hertz (New York: HarperCollins, 1971), 4.

2. K. Shuzo, "The Structure of the *Iki*," in *The Structure of Detatchment: The Aesthetic Vision of Kuki Shuzo*, ed. H. Nara (Honolulu: Hawaii University Press, 2004), 14.

3. J. Pigeot and H. Atsuko, "La structure d'iki," *Critique* 308 (1973): 40–52.

4. "By not talking about it, Kuki misses the importance of the Fluctuating World as the principal context for the manifestations and variations of *iki*," writes G. C. Calza, *Stile Giappone* (Turin: Einaudi, 2002), 27.

5. G. Carchia points out that there are possible Bergsonian influences still operating in Kuki's work. Carchia, "L'intuizione fiosofica e la carità dell'arte: Momenti dell'estetica bergsoniana," *Quaderni di estetica e critica* 1, no. 1 (1996): 81. In the essay, Carchia holds that Bergsonian aesthetic "does not have anything in common with the manieristic-baroque idea of *ars est celare artem.*" It is probable, though, that Carchia writes this having in mind only *one* of the possible meanings of *artem celare*: that according to which it would amount to a glorification of the highest degree of artificiality and of the deceptive character of art. Carchia indeed defines the principle as "manieristic and baroque," although, as we have started to see, it can become one of the keywords of classicism.

6. Shuzo, "The Structure of the *Iki*," 16.

7. Ibid.

8. Ibid., 21.

9. Ibid., 38.

10. Ibid., 46–55. The coexistence of ethic and aesthetic elements is also characteristic of the Chinese concept of "tasteless," which is relevant to our main theme as well. See F. Jullien, *In Praise of Blandness: Proceeding from Chinese Thought and Aesthetics* (New York: Zone, 2004).

11. See the Italian edition of Kuki Shūzō, *La struttura dell'Iki*, trans. and ed. Giovanna Baccini (Milan: Adelphi, 1992), 59, 64, 71, 91, and 111.

12. See on this the observations of Calza, *Stile Giappone*, 29.

13. B. Watson, ed. and trans., *The Complete Works Of Chuang Tzu* (1968; New York: Columbia University Press, 2013), chap. 3, pp. 19–20. The passage is quoted in the Italian translation in B. Saint-Girons, *Fiat Lux: Una filosofia del sublime*, trans. C. Calì and R. Messori (Palermo: Aesthetica, 2003), 183–84.

14. G. Pasqualotto, *Estetica del vuoto: Arte e meditazione nelle culture d'Oriente* (Venice: Marsilio, 1992), 24.

15. E. Herringel, *Zen in the Art of Archery*, trans. R. F. C. Hull (London: Routledge and Kegan Paul, 1953). Recently, many doubts have been

raised about Herrigel and his acquaintance with Japanese culture (see, for example, R. Needham, *Exemplars* [Berkeley: University of California Press, 1985]), but for reasons that do not seem convincing. After all, Herrigel's book was praised by D. T. Suzuki, the scholar who contributed the most to the introduction of Zen in Western culture.

16. Ibid., 17–19.
17. Ibid., 20–26.
18. Ibid., 26 and 35.
19. Ibid., 43 and 57.
20. Calza, *Stile Giappone*, 31–34.
21. Herrigel, *Zen in the Art of Archery*, 49.

7. THOSE WHO CANNOT DISSIMULATE CANNOT RULE EITHER

1. Lucian, *De saltatione*, trans. A. M. Harmon (1936; Cambridge: Harvard University Press, 1962), 285.
2. Xenophon, *On the Art of Horsemanship*, in *Works in Seven Volumes*, vol. 7, trans. E. C. Marchant and G. W. Bowersock (Cambridge: Harvard University Press, 1925), 11.6.
3. Ovid, *Ars Amatoria*, bk. 2, lines 311–14; English translation by W. Congreve, in *The Art of Love in Three Books, the Remedy of Love: The Art of Beauty: The Court of Love: The History of Love and Amours* (New York: Blanchard, 1855).
4. Ovid, *Ars Amatoria*, bk. 1, lines 457–61.
5. M. Equicola, *Libro de natura de amore* (Venice: Giolito, 1525), my own translation.
6. The idea of *sprezzatura* will be applied to singing by Giulio Caccini (1550–1618) in his *Le nuove musiche* (1602): one must sing "outside measures, as he is speaking harmonically . . . with *sprezzatura*." See on this G. Stefani, the entry *Barocco* in *Dizionario enciclopedico universale della musica e dei musicisti*, vol. 1 (Turin: UTET, 1983).
7. B. Castiglione, *The Book of the Courtier*, trans. L. E. Opdycke (New York: Scribner's, 1903), bk. 1:37.
8. Ibid., bk. 1:38.
9. Ibid., bk. 1:46.

10. As an introduction to this theme, see R. Villari, *Elogio della dissimulazione: La lotta politica del Seicento* (Rome: Laterza, 1987).

11. J. Snyder, "Appunti sulla politica e l'estetica della dissimulazione tra Cinque e Seicento," *Cheiron* 22 (1994): 23–43. See also J. Snyder, *Dissimulation and the Culture of Secrecy in Early Modern Europe* (Berkeley: University of California Press, 2009); on the relation between dissimulation and politics, a book that is still valid is Leo Strauss, *Persecution and the Art of Writing* (Chicago: University of Chicago Press, 1952).

12. On the dissimulation of one's own faith, see C. Ginzburg, *Il Nicodemismo: Simulazione e dissimulazione religiosa nell'Europa del '500* (Turin: Einaudi, 1970); A. Biondi, *La giustificazione della simulazione nel Cinquecento* (Florence: Sansoni, 1974).

13. R. Mercuri in his "Sprezzatura e affettazione nel *Cortegiano*" in *Studi in onore di Natalino Sapegno*, ed. W. Binni (Roma: Bulzoni, 1975) gives emphasis to the different political context of the *Courtier* compared with later treatises on the same topic. In that book emphasis is given also to the role of simulation.

14. Ph. de Vienne, *Le philosophe de court*, ed. P. M. Smith (Geneva: Droz, 1990), 156.

15. S. Guazzo, *The Art of Conversation: In Three Parts* (London, 1738), 63 (available at the website of the British Library).

16. T. Tasso, *Il Malpiglio over de la corte*, in *Dialoghi*, ed. E. Raimondi (Florence: Sansoni, 1958), vol. 2, bk. 2, pp. 557–60.

17. T. Accetto, *Della dissimulazione onesta*, ed. S. S. Nigro (Genoa: Costa and Nolan, 1983), 42–43, 59, 75, 44–45.

18. Rabelais, *Gargantua and Pantagruel*, trans. Thomas Urquhart of Cromarty and Peter Antony Motteux (1653; Derby: Moray, 1894), bk. 5, chap. 22.

19. B. Gracián, *El Héroe*, in *Obras Completas*, ed. E. Correa Calderón (Madrid: Aguilar, 1944), Primor 13; B. Gracián, *The Art of Worldly Wisdom*, trans. J. Jacobs (New York: Macmillan, 1892), 74.

20. Gracián, *El Héroe*, Primor 17.

21. Gracián, *The Art of Wordly Wisdom*, 7.

22. Ibid., 71–72.

23. It seems that the *Discours* was not directly written by La Rochefoucauld, but by La Chapelle-Bessé, but this is not of particular importance to our concerns.

24. F. de la Rochefoucauld, *Reflections; or Sentences and Moral Maxims*, trans. J. W. Willis Bund, MA, LLB, and J. Hain Friswell (Marston: Simpson Low, Son, 1871), maxims 289, 124, 245, 170.

25. N. de Chamfort, *Maximes, pensées, caractères et anecdotes* (Paris: Garnier-Flammarion, 1968), no. 204.

26. G. Leopardi, *Zibaldone*, ed. M. Caesar and F. D'Intino (New York: Farrar, Straus and Giroux, 2013), no. 4140.

27. J. de la Bruyère, *The Characters*, trans. Henri Van Laun and J. C. Nimmo (London, 1885), 114.

28. Castiglione, *The Book of the Courtier*, bk. 2, 80.

29. M.lle de Scudéry, *Conversations nouvelles sur divers sujets*, vol. 7, *De l'air galant*, quoted in E. Köhler, "Je ne sais quoi: Ein Kapitel aus der Begriffsgeschichte des Unbegreiflichen," *Romanistisches Jahrbuch* 6 (1953–54): 21.

30. M. Proust, *In Search of Lost Time*, trans. C. K. Scott Moncrieff and T. Kilmartin (New York: Random House, 2003), 2:756–57.

8. TRUE ELOQUENCE MOCKS ELOQUENCE

1. M. G. Vida, *De arte poeticae libri tres*, ex officina Roberti Stephani (Paris, 1527): "All things should come naturally, that desire to wander should remain concealed, and each remarkable work should conceal its art."

2. Philip Sidney, *An Apology for Poetry (Or The Defence Of Poesy): Revised and Expanded Third Edition*, ed. G. Shepherd and R. W. Maslen (Manchester: Manchester University Press, 2002), 114–15. As far as Sidney's knowledge of the *Courtier* is concerned, see D. Connel, *Sir Philip Sidney: The Maker's Mind* (Oxford: Clarendon, 1977), 5.

3. Ibid., 113.

4. R. Puttenham, *Art of English Poesie* (Kent, OH: Kent State University Press, 1970), 308–9.

5. J. Dryden, "To My Honoured Friend, Sir Robert Howard, on His Excellent Poems," in *The Poems of John Dryden*, ed. J. Kinsley, vol. 1 (Oxford: Clarendon, 1958).

6. The quotation from Horace, whose knowledge I owe to the kind reporting of G. Lombardo, is to be found in *Epistles*, 2.2.109–10.

7. Quoted in L. Anceschi, "La poetica del Bartoli," in *L'idea del Barocco: Studi su un problema estetico* (Bologna: Nuova Alfa Editoriale, 1984),

209–10. Anceschi has dealt with the rule *ars est celare artem* also in "Distinzione dell'arte," in *Saggi di poetica e di poesia* (Florence: Parenti, 1942), with particular reference to Gracián and Leopardi.

8. N. Boileau, "Art Poétique," in *Oeuvres* (Paris: Garnier, 1961), canto 1, lines 101–2, and canto 2, lines 71–72 ("Choose better the tone. Keep yourself deliberately simple, sublime without arrogance, gracious without flourish"; "Its impetuous style seems to look along. Under its domain a mess becomes beautiful as an effect of art").

9. G. Gravina, "Della Ragion Poetica," in *Scritti critici e teorici*, ed. A. Quondam (Rome: Laterza, 1973), 203–4.

10. L. A. Muratori, *Della perfetta poesia italiana*, ed. A. Ruschioni (Milan: Marzorati, 1971), 476–78 and 540–41.

11. On the role of *artem celare* in the poetics of French classicism, see J. C. Lapp, *The Esthetics of Negligence: La Fontaine's Fables* (Cambridge: Cambridge University Press, 1971).

12. Antoine Gombaud Chevalier de Méré, *Les Conversations* (1668), in *Oeuvres Complètes*, ed. C. H. Boudhors (Paris: Roches, 1930), 3rd conversation.

13. Ibid., 3:144. About the background pertaining to Méré and his views on rhetoric, see the wide tapestry offered by B. Craveri, *La civiltà della conversazione* (Milan: Adelphi, 2002).

14. F. de Fénelon, *Dialogues sur l'éloquence en général* (Paris: Garnier, 1866), 7; English translation: Fénelon, *Fénelon's Dialogues on Eloquence*, trans. Wilbur Samuel Howell (Princeton: Princeton University Press, 1951), 96.

15. Ch. Perelman and L. Olbrechts-Tyteca, *The New Rhetoric: A Treatise on Argumentation* (Notre Dame: Notre Dame University Press, 1969), 442.

16. On this subject, see the remarks by S. Velotti, *Storia filosofica dell'ignoranza* (Rome: Laterza, 2003), 4–7.

17. Heinrich Lausberg, David E. Orton, and R. Dean Anderson, eds., *Handbook of Literary Rhetoric: A Foundation for Literary Study* (Leiden: Brill, 1998), §292.

18. B. Pascal, *Pensées*, trans. W. F. Trotter, intro. T. S. Eliot (New York: Dover, 2003), 4.

19. For the broadening of this distinction to aesthetic discourse, first established in the field of language by N. Chomsky, see E. Garroni, *Creatività* (Macerata: Quodlibet, 2010).

20. From different points of view, two books have drawn attention to the aesthetics of *délicatesse*: the classic essay by A. Baeumler, *Das Irrationalitätsproblem in der Aesthetik und Logik des 18. Jahrhunderts bis zur Kritik der Urteilskraft* (1923; Darmstadt: Wissenschaftliche Buchgesellschaft, 1981), and, more recently, Luc Ferry, *Homo Aestheticus: The Invention of Taste in the Democratic Age*, trans. Robert de Loaiza (Chicago: University of Chicago Press, 1994), originally published in 1990.

21. See P. D'Angelo and S. Velotti, *Il "non so che": Storia di un'idea estetica* (Palermo: Aesthetica, 1997); and B. Riado, *Le je-ne-sais-quoi: Aux sources d'une théorie esthétique au XVII Siècle* (Paris: L'Harmattan, 2012).

22. D. Bouhours, in D'Angelo and Velotti, *Il "non so che,"* 81–84.

23. D. Bouhours, *Les Entretiens d'Ariste et d'Eugène* (Paris: Armand Colin, 1962), conversation 2, pp. 215–16.

24. B. Feijóo, "Il non so che," in D'Angelo and Velotti, *Il "non so che,"* 110–11 (Italian translation by author).

25. Montesquieu, *An Essay on Taste* (London: A. Millar, 1764), 284.

26. Ibid., 285–86.

27. Ibid., 286–300.

28. J. Joubert, *Carnets*, ed. A. Beaunier (Paris: Gallimard, 1938), X, 18, 878 e II, 03, 368–69. On these themes, see V. Magrelli, *La casa del pensiero* (Pisa: Pacini, 1995), 144ff.

29. G. Leopardi, *Zibaldone*, ed. by M. Caesar and F. D'Intino (New York: Farrar, Straus and Giroux, 2013), no. 202.

30. Ibid., no. 204.

31. Ibid., nos. 189–90.

32. Ibid., no. 100.

33. Ibid., no. 50.

34. Ibid., no. 20. On *sprezzatura* and *celare artem* in Leopardi, see A. Olivetti, "Figurato sublime," in *Oro in penombra* (Fiesole: Cadmo, 2003), 39–55.

9. READY-MADES

1. Danto, "The Artworld," *Journal of Philosophy* 61, no. 19 (1964): 571–84.

2. Ibid., 581.

3. G. Dickie, *Art and the Aesthetic: An Institutional Analysis* (Ithaca: Cornell University Press, 1974), 32–33; see also page 38.

4. D. Matravers, "The Institutional Theory: A Protean Creature," *British Journal of Aesthetics* 40, no. 2 (2000).

5. A. C. Danto, "Art in Response," in *Robert Irwin*, ed. R. Ferguson (Los Angeles: Museum of Contemporary Art, 1993), 151.

6. A. Julius, *Transgressions: The Offences of Art* (Chicago: University of Chicago Press, 2003), 124.

7. W. Hofmann, *Die Grundlagen der modernen Kunst: Eine Einführung in ihre symbolischen Formen* (Stuttgart: Kröner, 2004), chap. 10.

8. W. Cahn, *Masterpieces: Chapters on the History of an Idea* (Princeton: Princeton University Press, 1979).

9. On modern art as a play *with* the rules as well as *within* them, see K. Varnedoe, *A Fine Disregard: What Makes Modern Art Modern* (New York: Abrams, 1990).

10. Fr. W. Schelling, *System of Transcendental Idealism*, trans. Peter Heath (1800; Charlottesville: University of Virginia Press, 1993), 223–24.

11. I. Kant, *Anthropology from a Pragmatic Point of View*, trans. and ed. Robert B. Louden (Cambridge: Cambridge University Press, 2006), 188–89, italics mine.

12. I. Kant, *Critique of Judgment*, trans. P. Guyer and E. Matthews (Cambridge: Cambridge University Press, 2002), §45.

13. Jon Elster, in the third chapter of his *Ulysses and the Sirens: Studies in Rationality and Irrationality* (Cambridge: Cambridge University Press, 2013), titled "Problematic Rationality," insisted on the importance of bonds in artistic creation. Elster's skepticism for contemporary art brings, however, the author to claim that the diminishment of constraints brings to a downgrading of art, which clearly clashes with what it has argued so far. More generally, for what regards the function of the constraints of normativity, see M. Di Monte and M. Rotili, eds., *Vincoli/Constraints* (Milan: Mimesis, 2008); for more in particular on the artistic constraints, see, in that text, D'Angelo, "I vincoli nell'arte e l'arte di nasconderli" ("Constraints in Art and the Art of Concealing Them"), 47–63.

14. Goodman, in fact, is well aware of this. See, for example, Goodman, *Languages of Art: An Approach to a Theory of Symbols* (Indianapolis: Hackett, 1976), chap. 6, §5.

INDEX